Painting
weathered
Buildings
in pen, ink
& watercolor

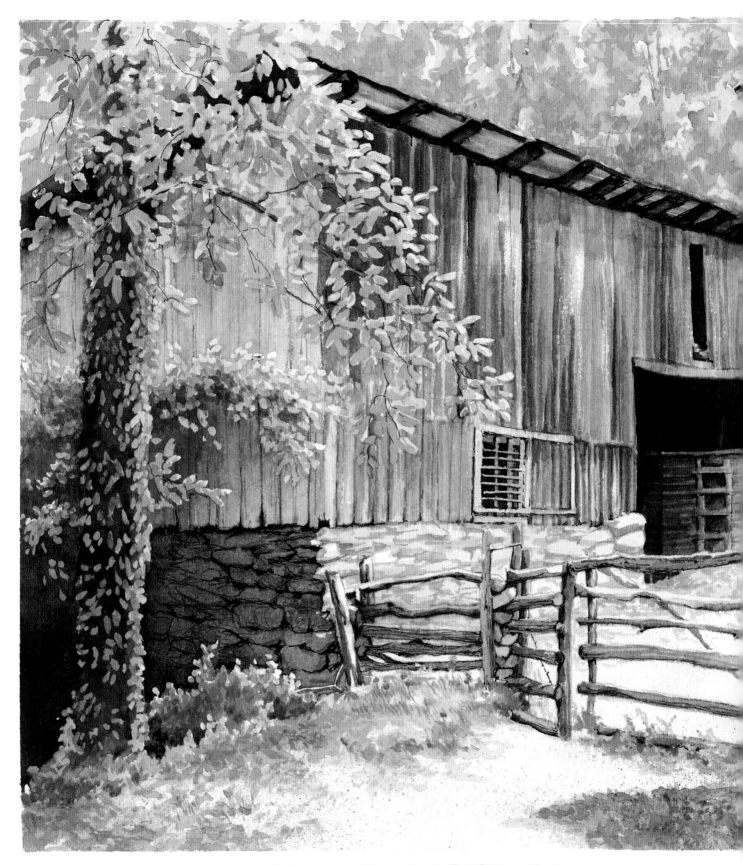

FILTERED LIGHT AND WEATHERED WOOD, 8″ × 10″ (20cm × 25cm)
Layered watercolor wash and black and Sepia pen work. Crumpled facial tissue
blotting, masking and spatter techniques were used on the foliage.

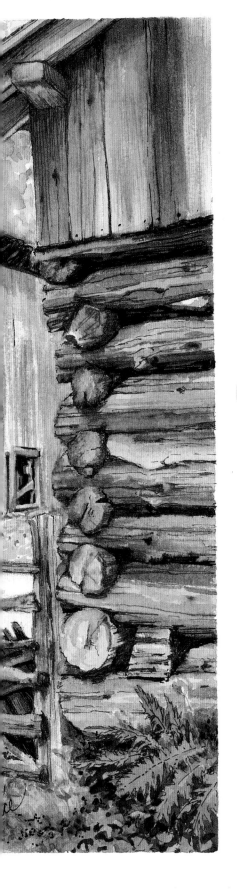

Painting **weathered** Buildings in pen, ink & watercolor

CLAUDIA NICE

NORTH LIGHT BOOKS
CINCINNATI, OHIO
www.artistsnetwork.com

Other fine North Light Books are available from your local bookstore, art supply store or direct from the publisher.

10 09 08 07 06 7 6 5 4 3

Library of Congress has catalogued the hardcover edition as follows:

Nice, Claudia.
 Painting weathered buildings in pen, ink & watercolor with Claudia Nice / Claudia Nice.
 —1st ed.
 p. cm.
 Includes index.
 ISBN-13: 978-0-89134-917-4 (pob)
 ISBN-10: 0-89134-917-0 (pob)
 ISBN-13: 978-1-58180-432-4 (pbk.: alk. paper)
 ISBN-10: 1-58180-432-6 (pbk.: alk. paper)
 1. Pen drawing—Technique. 2. Watercolor painting—Technique. 3. Buildings in art.
 I. Title.

NC905.N529 2000
751.42'244—dc21 99-045766
 CIP

Editor Mike Berger
Production editor Amy J. Wolgemuth
Cover designer Mary Barnes Clark
Production artist Deborah Gonzalez
Production coordinator Kristen Heller

ABOUT THE AUTHOR

Claudia Nice is a native of the Pacific Northwest and a self-taught artist, developing her realistic art style by sketching from nature. She is a multi-media artist, but prefers pen, ink and watercolor when working in the field. Claudia has been an art consultant and instructor for Koh-I-Noor Rapidograph and, more recently, Grumbacher. She travels across North America conducting workshops, seminars and demonstrations at schools, clubs, shops and trade shows. Her oils, watercolors and ink drawings have won numerous awards and can be found in private collections across the continent.

Claudia has authored fourteen successful art instruction books, including *Sketching Your Favorite Subjects in Pen & Ink*, *Creating Texture in Pen & Ink With Watercolor*, and *Painting Nature in Pen & Ink With Watercolor*, all of which were featured as main selections in the North Light Book Club.

When not involved with her art career, Claudia enjoys hiking and horseback riding in the wilderness behind her home on Mt. Hood in Oregon. Using her artistic eye to spot details, Claudia has developed skills as a man tracker and is involved, along with her husband Jim, as a wilderness search and rescue volunteer.

My thanks to Mike Berger, David Lewis, Greg Albert and my husband Jim, for all the help and encouragement they gave me—

And to the Carpenter of Nazareth, who taught me to build my house on a firm foundation. Matt. 7:24-25

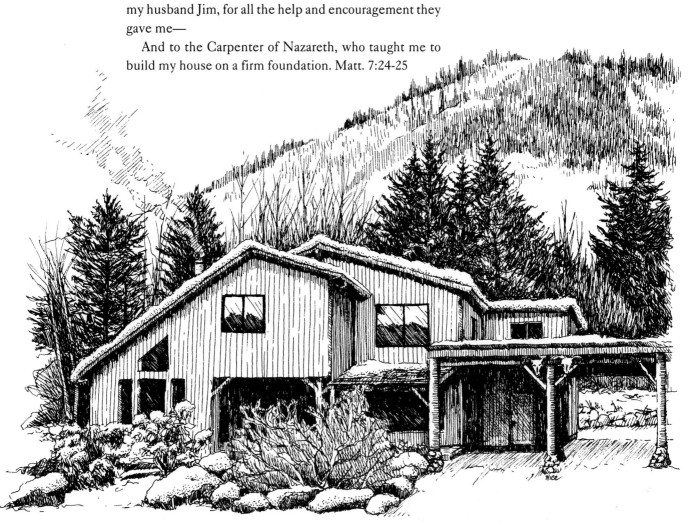

Bright Wood Meadows—the author's mountain home.

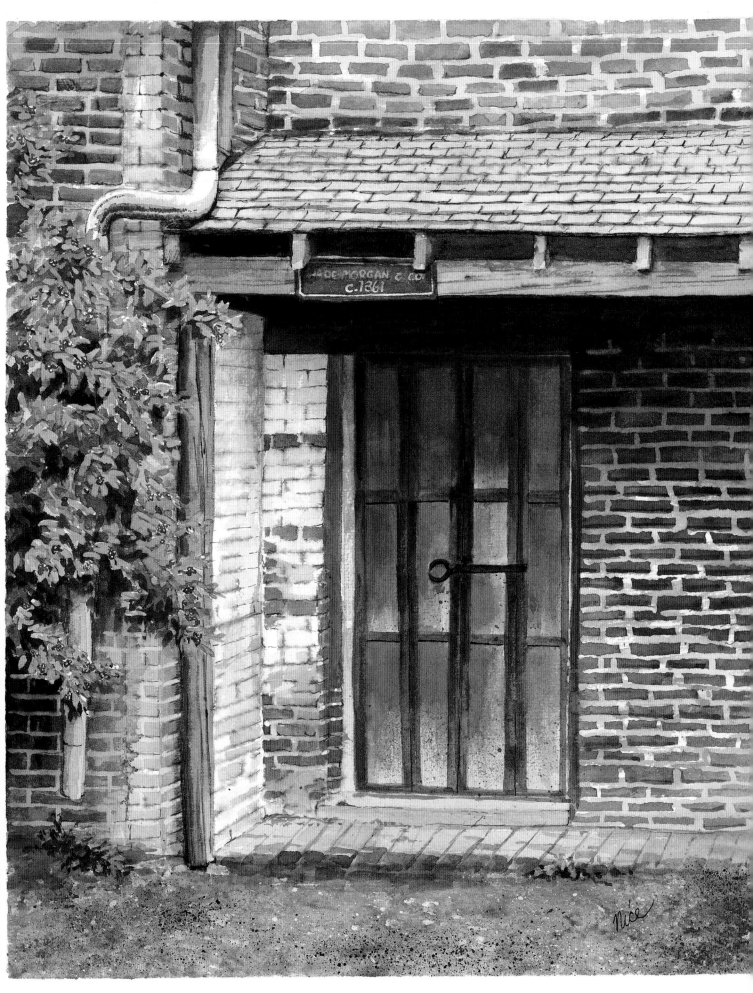

RED IRON DOOR, 10″×8″ (25cm×20cm)
Detailed with gray and Sepia pen and ink work.

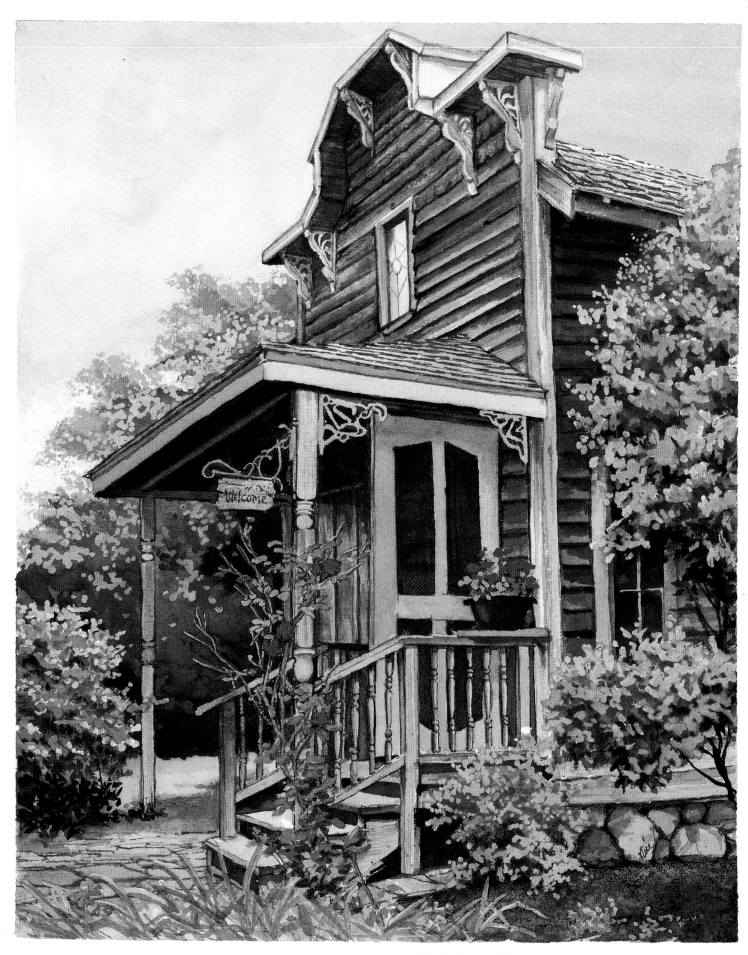

WEATHERED WOOD VICTORIAN, 8″×10″ (20cm×25cm)
Watercolor painting enhanced with pen and ink.

INTRODUCTION

Why are old buildings so intriguing? Could it be the hands that built them, using simple tools and passed down skills, that garners our curiosity and respect. Or is it the earthy materials they are made from—wood, stone and brick—that reminds us of ancestral times when man and nature lived closer together? Whatever the reason, old buildings are fascinating. They have a beauty all their own, clothed in dignified, sun-softened colors and weathered earth tones. Some stand proud and true to form, a credit to their builder. Others sag under the weight of years with missing shingles and broken panes. Yet these imperfections only seem to add to their charm, drawing people closer, as if we could somehow gather ancient wisdom by peeking into dusty windows and abandoned rooms. The word describing this longing is *nostalgia*. For those who have felt nostalgia as they entered the cool shadows of an old barn, or marveled at the details of an old Victorian dwelling, or simply stroked a piece of sunwarmed wood for the feel of it, this book is for you. May it please the eye of the one who merely wants to ponder the past, and inspire the artist who wants to capture both structural shape and moood with his own hand.

Happy sketching,

MATERIALS & TECHNIQUES

MATERIALS

Good tools and art supplies are essential to the success of a project. The learning process and the joy of creation can be greatly discouraged when the artist has to fight with his art equipment in order to succeed. One need not buy the most expensive tool, but he must learn the nature of that implement so as to choose wisely within an affordable price range.

Paper

The sketch paper should be polished enough to allow the pen to glide over its surface without snagging, picking up lint or clogging. The ink should also appear crisp. For mixed media, choose a paper that is compatible with pen work, as well as wet washes. The watercolor paper must be absorbent enough to avoid *permanent* buckling when wet-on-wet techniques are used. Taping the edges of the paper to a board while painting will help the paper maintain its original shape. My favorite watercolor paper is Fabriano Uno (Savoir Faire) 140-lb. (300gsm) cold-press.

Pen

The ideal pen has a steady, leak-free flow and a precise nib that can be stroked in all directions. This book was illustrated using Koh-I-Noor Rapidograph pens. Each pen consists of a hollow nib, a self-contained, changeable ink supply and a plastic holder. Within the hollow nib is a delicate wire and weight that shifts back and forth during use, bringing the ink forward. The Rapidograph comes in a variety of sizes, (0.25mm) being the one used most often in my work. (Nib sizes are noted throughout the book in parentheses.) Drawbacks: cost and maintenance. Like any instrument, the Rapidograph pen requires proper care and cleaning.

A more economical and maintenance-free version of the technical pen is the disposable Artist Pen by Grumbacher. It comes prefilled with a quality, brush-proof ink. The Artist Pen is similar in usage to the Rapidograph but differs somewhat in design, the inner workings being sealed. Drawbacks: The artist does not have a choice of inks and empty pens are not refillable.

Dip pens are very economical, consisting of a plastic or wooden holder and changeable steel nibs. With Hunt nib no. 102 (medium) or no. 104 (fine), the Crow Quill dip pen provides a good ink line. It cleans up easily and is useful when many ink changes are required. Drawbacks: Crow Quill pens are limited in stroke direction, must be re-dipped often and tend to drip and spatter.

Ink

For mixed media work, choose an ink that is lightfast, compatible with the pen you are using and brush proof, withstanding the vigorous overlay application of wet washes without bleeding or streaking. Permanent inks are not necessarily brush proof and must be tested. For a very black, brush-proof India ink, I recommend Koh-I-Noor's Universal Black India 3080.

For softer, subtle ink lines, choose compatible, brush-proof colored inks. Transparent, pigmented, acrylic-based inks are preferred, as dye-based inks often fade quickly. I used Koh-I-Noor Drawing Ink 9065 for the colored ink work in this book. However, the White and Black 9065 is not recommended for technical pens.

Paint

Look for a watercolor paint that has rich, intense color, even when thinned to pastel tints. It should be finely ground and well processed, with no particle residue, so washes appear clean. Colors should have high lightfast ratings. The paintings in this book were created using Grumbacher, M. Graham and Winsor & Newton watercolors. Whichever brand you choose, remember that it is better to have a limited palette of quality paints than a kaleidoscope of inferior substitutes.

Brushes

The best watercolor brushes are made of sable hair. Soft, absorbent sable brushes are capable of holding large amounts of fluid color, while maintaining a sharp point or edge. They respond to the hand with a resilient snap. However, they are expensive. A good sable hair blend or a quality synthetic brush can provide an adequate substitute. Avoid brushes that become limp and shapeless when wet, or are so stiff they won't "flow" with the stroke of your hand. Upkeep hint: Use your watercolor brushes only for watercolor.

Other useful tools

- No. 2 pencil and white vinyl eraser
- Art masking fluid to protect white paper areas (Winsor & Newton)
- Old round brush for applying masking fluid (coat brush with soap and water before using)
- Masking tape for taping paper's edges and removing masking fluid
- Stylus or toothpicks for bruising
- Rock and table salt, alcohol, plastic wrap, spray mister, clean sand and so on, for texturing
- Tweezers for placing rock salt and impressed objects
- Razor blade for scratching through dry paint
- Several small sea and synthetic sponges for daubing
- Facial tissue and paper towels for blotting

For additional information on tools and techniques, refer to my other books: *Sketching Your Favorite Subjects in Pen & Ink*, *Creating Textures in Pen & Ink With Watercolor*, *Drawing in Pen & Ink* and *Painting Nature in Pen & Ink With Watercolor*, all published by North Light Books.

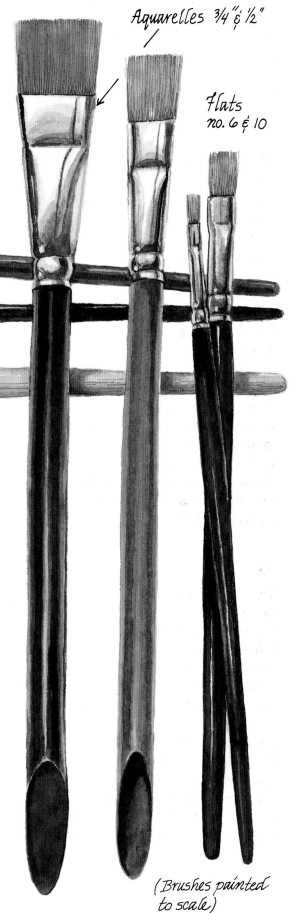

My favorite brush shapes and sizes ~

Aquarelles 3/4" & 1/2"

Flats no. 6 & 10

Sable round brushes no. 4 & 6

KOLINSKY

Squirrel or sable wash brush

(Brushes painted to scale)

11

Pen And Ink Techniques

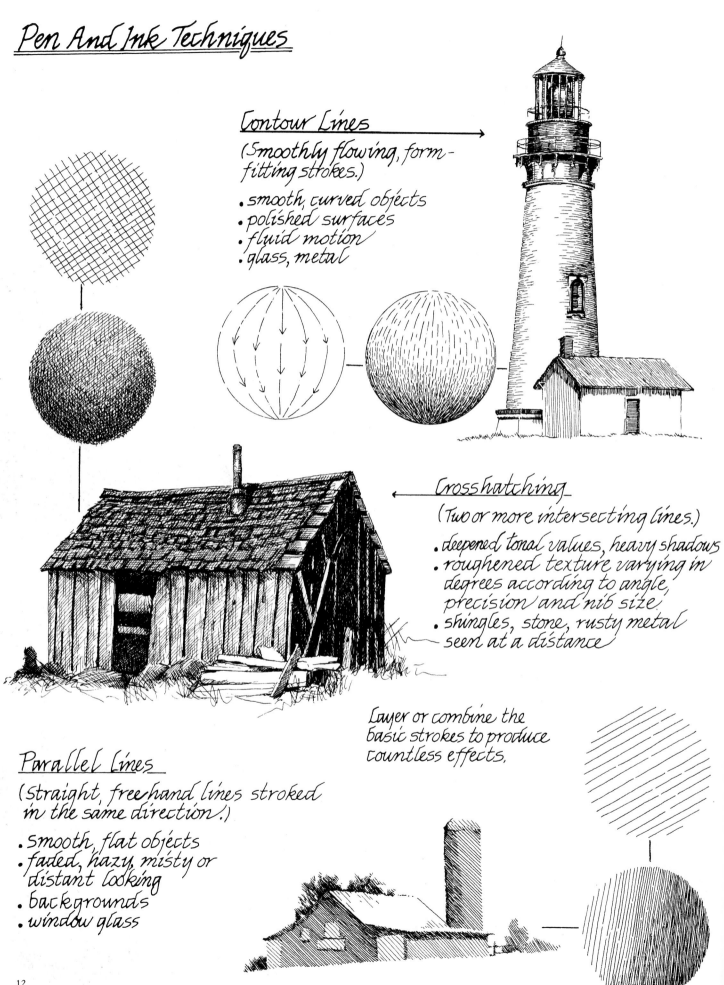

Contour Lines
(Smoothly flowing, form-fitting strokes.)

- smooth, curved objects
- polished surfaces
- fluid motion
- glass, metal

Crosshatching
(Two or more intersecting lines.)

- deepened tonal values, heavy shadows
- roughened texture varying in degrees according to angle, precision and nib size
- shingles, stone, rusty metal seen at a distance

Layer or combine the basic strokes to produce countless effects.

Parallel Lines
(Straight, freehand lines stroked in the same direction.)

- smooth, flat objects
- faded, hazy, misty or distant looking
- backgrounds
- window glass

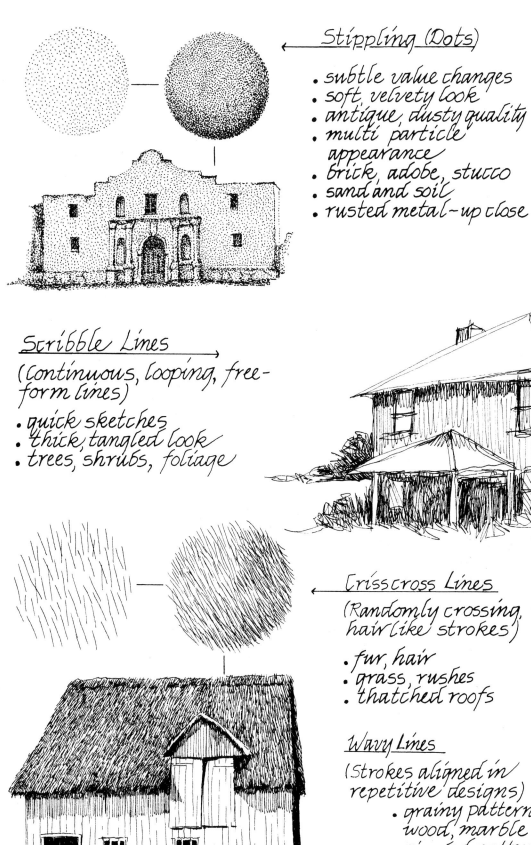

Stippling (Dots)

- subtle value changes
- soft, velvety look
- antique, dusty quality
- multi particle appearance
- brick, adobe, stucco
- sand and soil
- rusted metal – up close

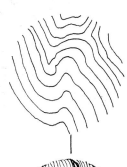

Scribble Lines

(Continuous, looping, free-form lines)

- quick sketches
- thick, tangled look
- trees, shrubs, foliage

Crisscross Lines

(Randomly crossing, hair like strokes)

- fur, hair
- grass, rushes
- thatched roofs

Wavy Lines

(Strokes aligned in repetitive designs)

- grainy patterns of wood, marble
- rippled patterns of water rings

Note: Shade wavy line objects with contour or crosshatch strokes.

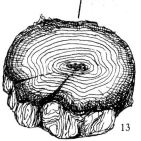

13

Basic Watercolor Palette ~

Begin with six intense "primary mixing colors," a warm and cool red, yellow and blue (shown as triangle shapes below). The colors listed are M. Graham & Co., Grumbacher and Winsor & Newton brand paints. A medial red, yellow and blue can be produced by combining the warm and cool representative of each hue.

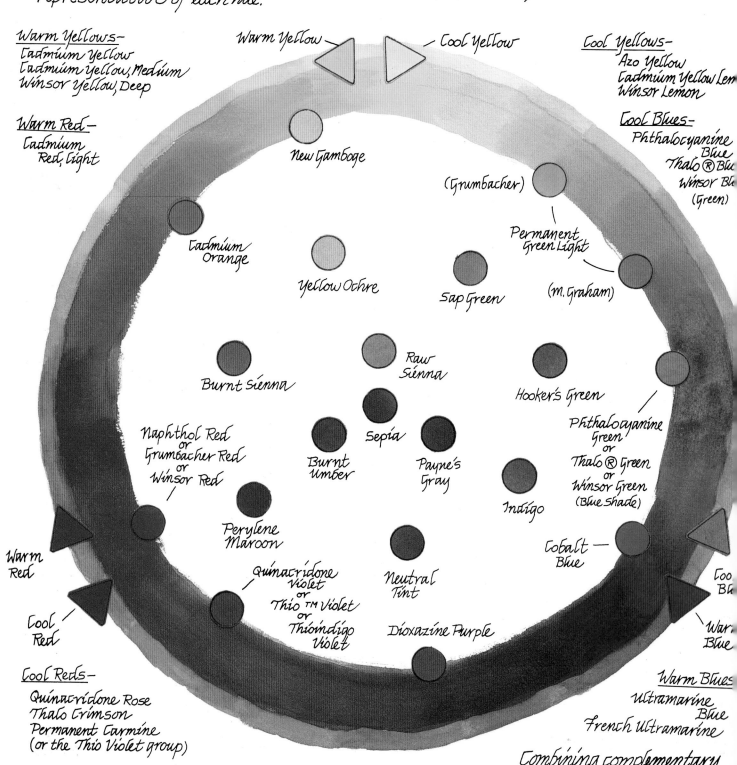

Warm Yellows—
Cadmium Yellow
Cadmium Yellow, Medium
Winsor Yellow, Deep

Warm Red—
Cadmium
Red, Light

Warm Yellow

Cool Yellow

Cool Yellows—
Azo Yellow
Cadmium Yellow Lem
Winsor Lemon

Cool Blues—
Phthalocyanine Blue
Thalo ® Blu
Winsor Bl
(Green)

New Gamboge

(Grumbacher)

Permanent Green Light

Cadmium Orange

Yellow Ochre

Sap Green

(M. Graham)

Burnt Sienna

Raw Sienna

Hooker's Green

Naphthol Red
or
Grumbacher Red
or
Winsor Red

Sepia

Burnt Umber

Payne's Gray

Phthalocyanine Green
or
Thalo ® Green
or
Winsor Green
(Blue Shade)

Perylene Maroon

Indigo

Cobalt — Blue

Warm Red

Quinacridone Violet
or
Thio ™ Violet
or
Thioindigo Violet

Neutral Tint

Dioxazine Purple

Coo
Blu

Cool Red

War
Blue

Cool Reds—
Quinacridone Rose
Thalo Crimson
Permanent Carmine
(or the Thio Violet group)

Warm Blues
Ultramarine Blue
French Ultramarine

Mix cool yellow with cool blue to make vibrant greens. Warm yellow combined with warm red will produce brilliant oranges. Mix cool red with warm blue for a range of vivid violets.

Combining complementary colors (those opposite each other on the color wheel) will produce natural shadow tones, clean earthy browns and muted neutral grays. The small colored circles shown above represent frequently used color mixtures that are convenient to have on hand in premixed tubes.

Complementary Color Mixing Chart

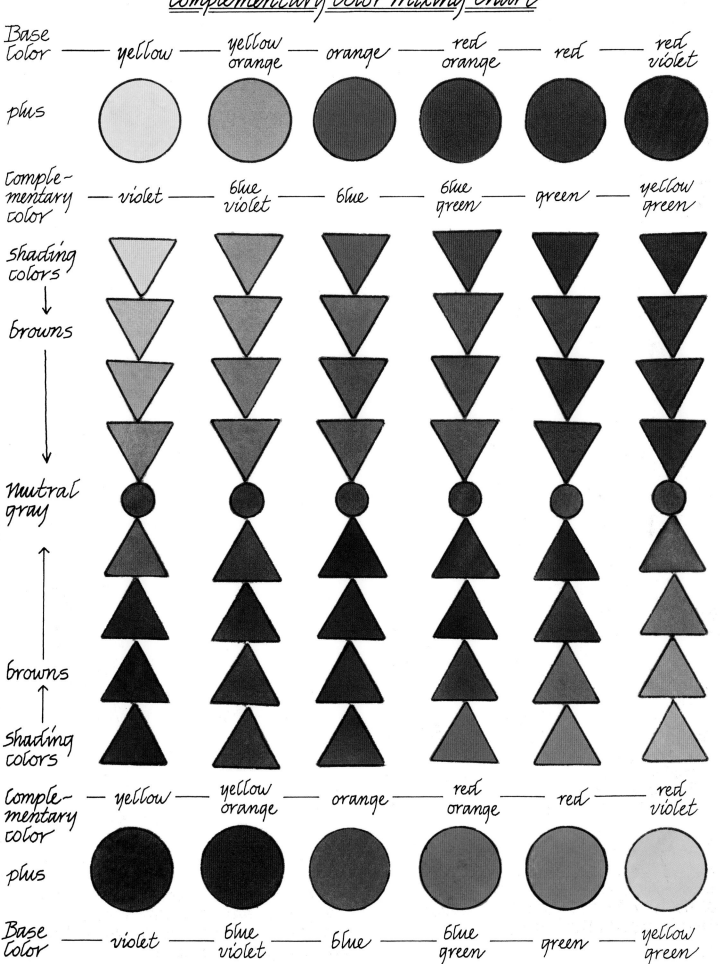

Dry Surface Techniques

Paint is absorbed quickly into a dry paper surface, producing crisp edges and paper-induced textures as the brush dries out.

Drybrushing is the application of a wash to a dry surface using a brush that has been blotted to remove excess moisture.

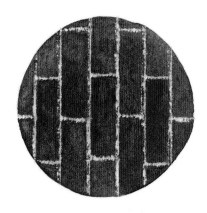

Layering ~ round detail brushstrokes applied over a dry wash.

Layered, flat brush stippling over a dry mottled wash.

Drybrushing ~ as paint is absorbed from the brush, texturing occurs.

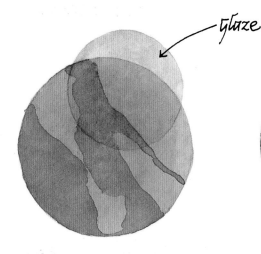

glaze

Glazing ~ thin, layered washes that subtly change the value or hue of the underlying paint. Each layer is allowed to dry before the next glaze is stroked on.

Masking ~ liquid masking fluid (frisket) applied over dry paper surfaces or dry washes to block areas from absorbing additional pigment. Remove used frisket with masking tape.

Scraping ~ scratching through a dry wash with a razor blade to reveal the white paper surface below.

Damp Surface Techniques

Pigment spreads easily when stroked over a moist (not shiny **wet**) surface, producing softened edges and smooth blends. However, use caution when painting over a moist wash, as lifting or puddling may occur.

Flat wash — paint is stroked quickly and smoothly over a damp surface and allowed to dry undisturbed.

Varied wash — two or more colors brushed smoothly over a damp surface. Note uniform blending of hues.

Graduated blend — increase or decrease the amount of pigment in the wash as it is brushed over a damp surface.

Blotting — press a crumpled facial tissue or other absorbent material into a moist wash to remove pigment.

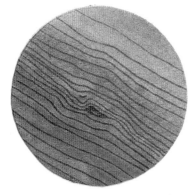

Bruising — stroking a stylus through a very moist base wash bruises the paper, producing dark lines where the pigment gathers in the disturbed areas.

Scraping — pulling a blunt tool firmly through a slightly moist wash pushes the pigment aside, creating a light design with dark edges.

Mottled wash — tap varied colors onto a damp surface with the edge of a flat brush, allowing the colors to mingle and blend freely.

Wet-On-Wet Techniques

Paint applied to a shiny wet surface will flow freely, creating spontaneous soft-edged, feathery designs. ⟶

(Avoid working on surfaces that are runny wet or puddled.)

Spontaneous design resulting from wet-on-wet application.

Spontaneous blend of two colors brushed over a wet surface.

Directional flow from a tilted paper.

Edge of wet wash sprayed with water from a spray mister bottle.

Puddling — additional liquid applied to a wet wash.

Water spots — water drops spattered or dripped into a wet wash.

Special Effects

When the application of the paint is varied, or the pigment is disturbed in some manner after it has been laid down, a texture may result. When the result is consistent, it becomes a technique. Here are some favorites.

Paint stamped on with a sponge.

Spatter — Paint flicked off a finger tip with a flat, paint filled brush.

Rubbing alcohol brushed through a moist, varied wash using a no. 4 round brush.

Drops of rubbing alcohol dripped and spattered into a moist wash.

Crumpled plastic wrap pressed into a moist wash and secured in place until dry.

Clean sand sprinkled into a wet wash and left until completely dry.

Rock salt granules, dipped in water and placed in a moist wash, and left undisturbed until all moisture is dried.

Note: Tweezers are helpful in placing rock salt granules.

Table salt sprinkled lightly into a very moist wash.

Note: For best results use thin, fluid washes and salt that has been dried in an oven or micro wave.

19

Smooth Textures

Flat washes or graduated blends are a good place to start when depicting smooth surfaces, such as glass, metal, polished stone, porcelain and pools of still water.

Flat wash *Graduated blend*

Ultramarine Blue plus orange

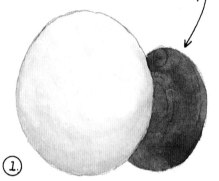

①

This glass door knob began as a graduated blend. The metal anchor piece started out as a flat wash.

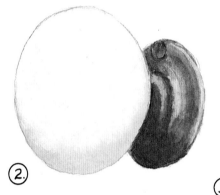

②

While the washes were still moist, highlights were lifted out with a round brush.

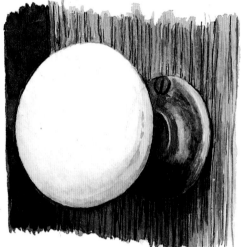

③

Finally:
Shadows and details were layered on with a no. 4 round brush and (.25) Rapidograph. A contrasting background completes the study.

Some interesting alternatives —

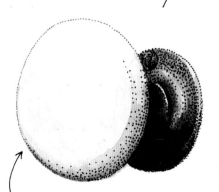

Stippled sepia pen work (.25) tinted with washes of sepia watercolor lends an aged, dusty look to the doorknob.

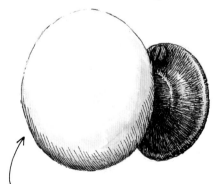

Black contour line pen work (.18) overlaid with light watercolor washes.

Note:
Smooth, rounded surfaces have graduated, well-blended value changes.

Smooth surfaces reflect light and may have strong white highlights.

20

A smooth, highly polished surface has an abundance of white highlights. It is strong in reflective color as well as local color, with quite a wide range of hues and value changes. Color and value changes may be subtly blended or abrupt, representing glare, sparkle and mirrorlike reflections.

A damp surface, varied-wash with lots of open white areas is a good way to depict smooth polished surfaces —

or for more control, try a layered technique as shown in the key sketch below.

Mixtures of Payne's Gray and Burnt Umber

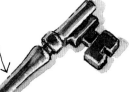

Ultramarine Blue and Yellow Ochre (applied separately)

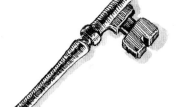

(A) Pale preliminary washes are brushed onto a damp surface, leaving plenty of unpainted white highlights. These light washes will represent reflected color and glimmer. Let dry.

(B) Layer on darker colors to represent local color (the actual color of the metal), dark reflections and shadows. Recapture lost highlights by scraping a razor blade across the surface.

The same key rendered in pen and ink using contour lines and a (.18) nib.

(The shadow beside the key is a watercolor wash.)

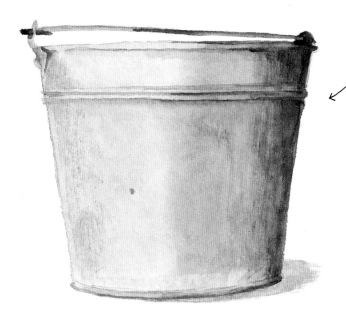

Smooth, dull surfaces, like the galvanized bucket shown here, are strong on local color but lack bright highlights and reflections.

The bucket sketch began as a graduated Payne's Gray wash. Details were layered on and blended with a damp brush. Drybrushing added a slightly roughened finish.

Rough Textures

Creating rough textures is not difficult.
Figuring out where and when to use them
may take some thought. Here are a few
of my favorites and some ideas on
putting the techniques to work.

All of these rough texturing
techniques started out
as damp surface,
varied washes.

Drybrush
texturing
(over dry,
varied washes).

Stippled drybrushing
(using the edge of a
½-inch flat brush.)

Drybrush stippling was
used to texture the
water in the
harbor sketch.

Pen and ink
crosshatching
layered over a
dry wash.

Note how the rough
detailing of the
rock wall pulls the
foreground towards
the viewer.

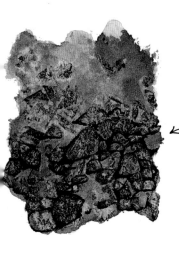

Moist, varied washes impressed with pieces of crumpled plastic wrap and left to dry.

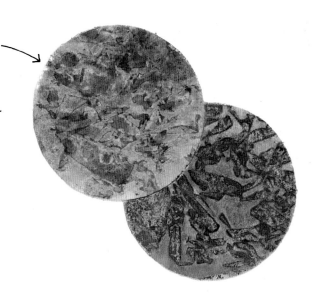

Plastic wrap-impressed textures can be used to suggest rough ground cover or distant rock rubble.

Damp surface, varied washes blotted with a finely textured paper towel.

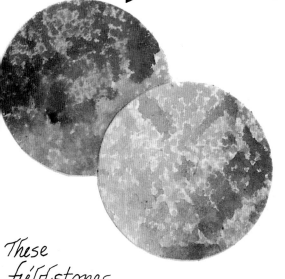

These fieldstones were scraped with a blunt tool while the varied washes were still slightly moist.

Spatter

Dry paint scraped with the flat edge of a razor blade.

Slightly moist wash scraped with a blunt tool.

23

Gritty Textures

To depict dusty, gritty, granulated surfaces, you can't beat stippling, spatter and sand-impressed washes.

Stippled, Sepia ink work (.25) laid over a dry Yellow Ochre wash.

Damp surface, varied wash sprinkled with sand and left un-disturbed until dry.

Spattering applied over a damp wash and a dry paper surface.

To depict the weathered patina of old iron, try the sand-impressed wash technique shown below. —

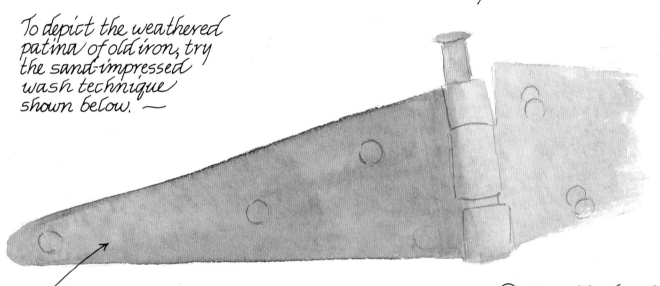

① Begin with a flat wash. Apply it to a damp surface and let it dry throughly. This represents the base or local color of the iron.

(Use a pale mixture of Indigo and Burnt Sienna.)

Sand-impressed texturing

② Over the dry base color, stroke on a varied wash of Yellow Ochre, Burnt Sienna and touches of Indigo. Sprinkle sand over the wet wash.

Note: The sand must be completely dry before brushing it off the painting.

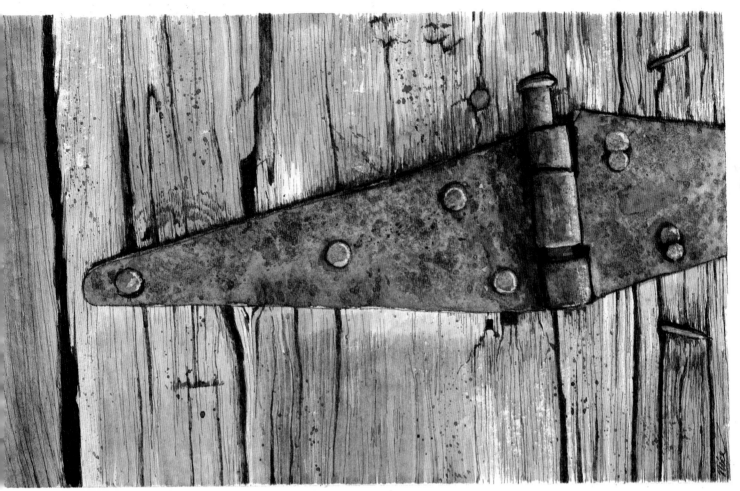

③ Use drybrushing and blending techniques to add details and shadows to the metal hinge. Scrape in highlights with a razor blade.

A touch of spatter across the hinge will accentuate the aged, metallic look.

A weathered, barnwood background completes the study. (The steps for depicting barnwood textures are shown in chapter three.)

The stucco wall and gravelly foreground are textured with stippled pen work.

(Gray and Sepia inks, in a (.25)-sized Rapidograph.)

Grainy Textures

Wavy lines applied with a pen, dry brushing or a stylus are the best way to suggest the undulating, repetitive patterns of wood grain.

Note: The closer the subject, the more detailed the grain lines become.

½"-flat brush, dry-brushed over a pale Burnt Umber wash. (Layered colors are Burnt Umber and Payne's Gray.)

Sepia (.25) pen work, tinted with washes of Burt Umber.

Dry brushing

Wavy ink lines

Bruised wood grain lines

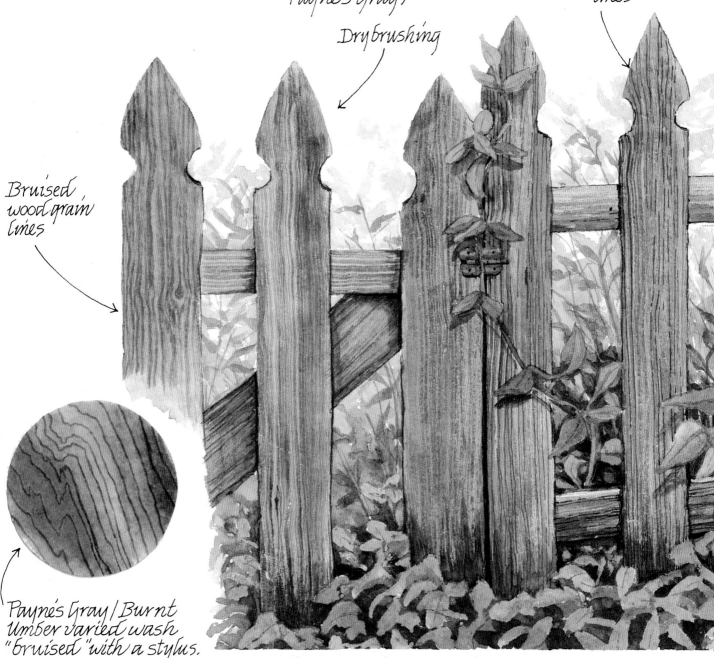

Payne's Gray / Burnt Umber varied wash "bruised" with a stylus.

To depict the foliated patterns of mineral deposits in granite and marble, begin with variegated damp surface washes.

Use less ink detailing for distant subjects.

Granite

① Table salt sprinkled in a Burnt Umber/ Payne's Gray wash.

② Payne's Gray spattered into the wash while it is still moist.

③ Detail with black ink (stippling & broken scribble lines).

Marble

① Alcohol brushed through a Thalo Green/ Payne's Gray wash.

② Moist wash spattered with water drops and Payne's Gray.

③ Black vein lines added with a (.25) pen.

Marble

① Pastel earth-tone washes are streaked over a damp surface, leaving plenty of white! Let dry.

② Remoisten the sur- face and add sepia pen lines. (Ink should "fray out.")

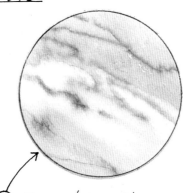

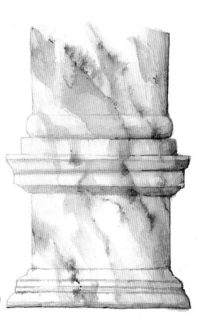

Thick, Tangled Textures

Crisscross and scribble line pen work are perfect for depicting the trees, shrubs and grass that so often surround buildings.

For a softer, more spontaneous look, begin with a watercolor special effect technique, such as sponging, plastic wrap or salt, and add drybrush or penwork to define the details.

Scribble line pen work (.25)

Crisscross lines (.25)

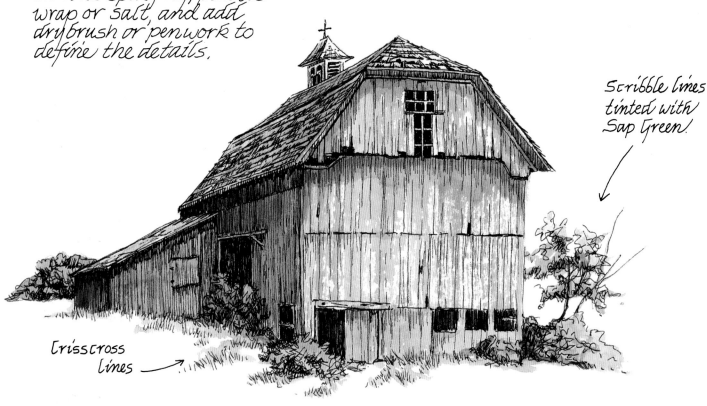

Scribble lines tinted with Sap Green.

Crisscross lines

Sponging ~

① Dampen a sea sponge, tap it into Thalo Yellow Green and Sap Green watercolors and daub it lightly onto the paper.

② Add a second layer of Sap Green to shade and shape the foliage.

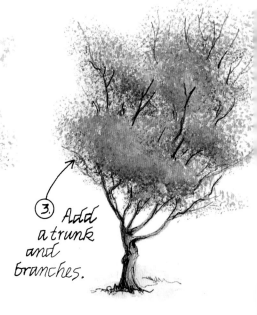

③ Add a trunk and branches.

Varied wash of Thalo Yellow Green, Sap Green and Ultra-marine Blue.

1. To create a spontaneous leafy texture, begin with a very moist wash.

Impressed plastic wrap ~

2. Crumple plastic wrap, press it into the wet wash, and secure it in place until the paint is dry. The pigment should gather into a random leaflike pattern.

3. Use Sap Green paint and a no. 4 round brush to darken the leaf shapes and add more leaves to fill in as needed. Branches are penned in with Sepia ink.

Salt ~

Salt sprinkled into a wet, mottled wash of Burnt Sienna and Sap Green produces a thick, soft, mosslike texture. This is nice to accent rock walls and shady flower gardens. A little Sepia pen scribble stroke enhances the look.

Stippled with the blunt edge of a flat brush

Sea sponge drag marks

Criss cross Sepia pen strokes (.25)

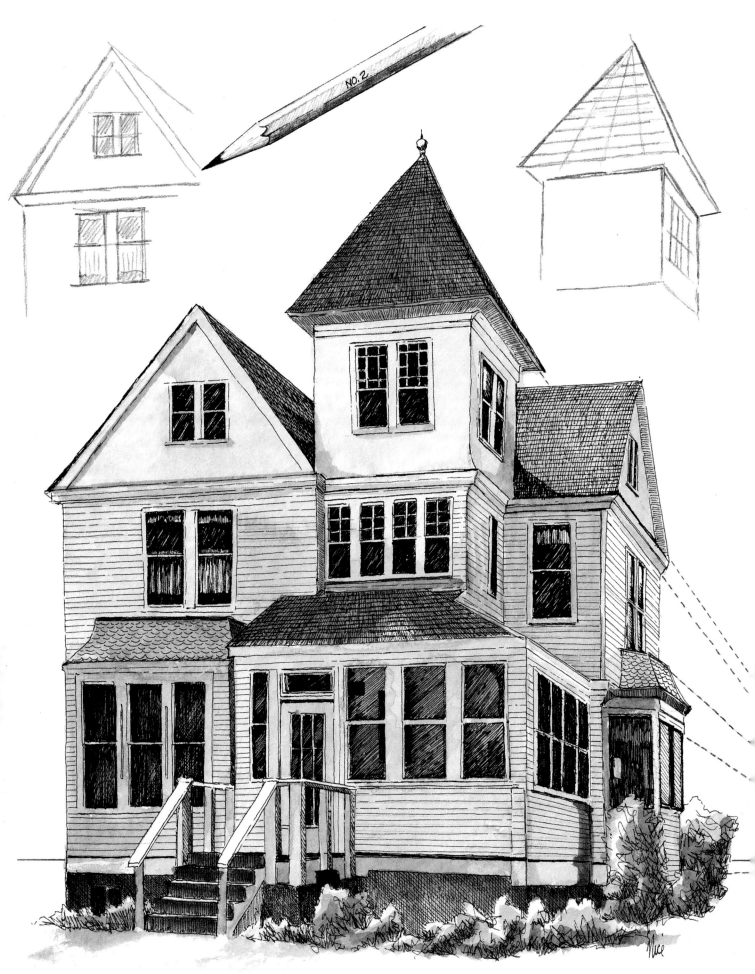

NO. 2

SKETCHING THE SUBJECT

When I was a child, I thought as a child (and drew as a child), and now that I am grown, well, hopefully I can see things from an adult perspective. And that's the key: taking time to observe and *really see* what you are looking at, instead of charging ahead with preconceived ideas. As Leondardo da Vinci said, "To see is to know," and once you know and understand the subject, it can be drawn.

Practice your observation skills, and your drawing skills will improve. Find a nearby building and study it for a couple of minutes, then turn away. What do you remember? How many windows did you see? Did they reflect light and images, or were they dark and shadowy? What was the color of the roof and door? How many steps led to the porch? Where did the sun strike the building the brightest? If you can answer these questions, then you are starting to see with an artist's eye.

Now pick up your pencil. Forget the thing you are drawing and record the shapes you see. The completed sketch may not be a perfect representation of the building, but you will probably have captured the essence of the subject. Now restudy the structure. Compare lines, shapes and angles between the original and your drawing. A straight edge will help. Make corrections, but remember that imperfection adds character.

This chapter is designed to give you help with the perspective and compositional aspects of drawing. I hope it will also encourage you to take a new and closer look at the world around you.

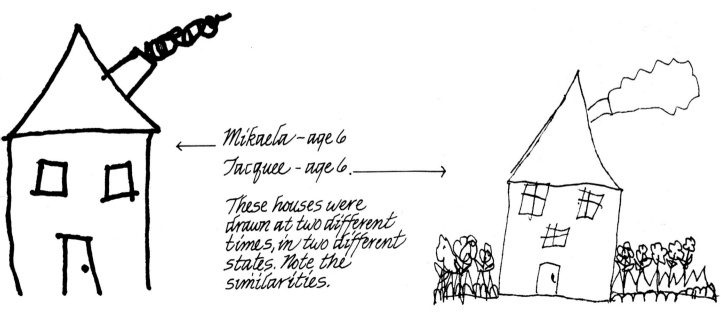

Mikaela – age 6

Jacquee – age 6.

These houses were drawn at two different times, in two different states. Note the similarities.

Basic Perspective

Perspective is the technique of depicting dimensional objects on a flat surface. It's helpful to know a few simple principles about perspective before attempting to draw buildings.

① The artist's horizon line is located at "eye level."

The viewer will look up to subjects above eye level (a) and down upon those below (c). Eye level subjects are viewed straight on (b).

With very few exceptions, there will be only one horizon line per drawing, and everything in that drawing will relate to it. (Note: Occasionally you will come across scenes where the ground slopes sharply away from the viewer and multiple planes of vision are beheld, but they are rare.)

vanishing point

a

b

horizon line (eye level)

These extended parallel lines converge off the paper.

c

② Objects appear to grow smaller as they recede into the distance, disappearing altogether at the "vanishing point." There may be more than one vanishing point in a composition, each one located somewhere along the horizon line.

Use diagonal lines, drawn corner to corner to determine the center of the side of a building. A vertical line drawn upward through the center of the "x" will provide an accurate ridge for the roof. The pitch of the roof is up to the artist, depending on how high the center ridge line is extended.

③ Lines that run parallel to each other, like the roof line, foundation and horizontal window edges, will appear to grow closer together, and if extended, will converge on the horizon line at a single vanishing point. Each side of the building viewed will have its own vanishing point.

If the extended parallel lines of a building do not converge at the appropriate vanishing point, the drawing is out of perspective.

Oblique
vanishing
point for
the roof pitch

④ A set of parallel diagonal lines, like the sides of a gabled roof (d & e), are not on a horizontal plane. Therefore, their vanishing point is not located along the horizon line.

To find the "oblique vanishing point" corresponding to the pitch of the roof run an extended line upward from the near edge of the gable - (d). Locate the vanishing point corresponding to the gabled side of the building and extend a vertical line upward from it. Where the two lines cross is the oblique vanishing point. Use it as a pivot point to plot the angle of the back gable - (e)

⑤ Vertical sides of a building are not shown to converge unless it's a sky scraper. Draw them straight.

left
V. P.

right
V. P.

d e

Although an artist may first plot horizon lines and vanishing points and lay out a preliminary drawing mechanically, most artists enjoy drawing the subject freehand, keeping the principles of perspective in mind. With practice, one can become quite accurate.

A free hand drawing, based on perspective principles.

Mechanical lay out ~ accurate, but rather stiff.

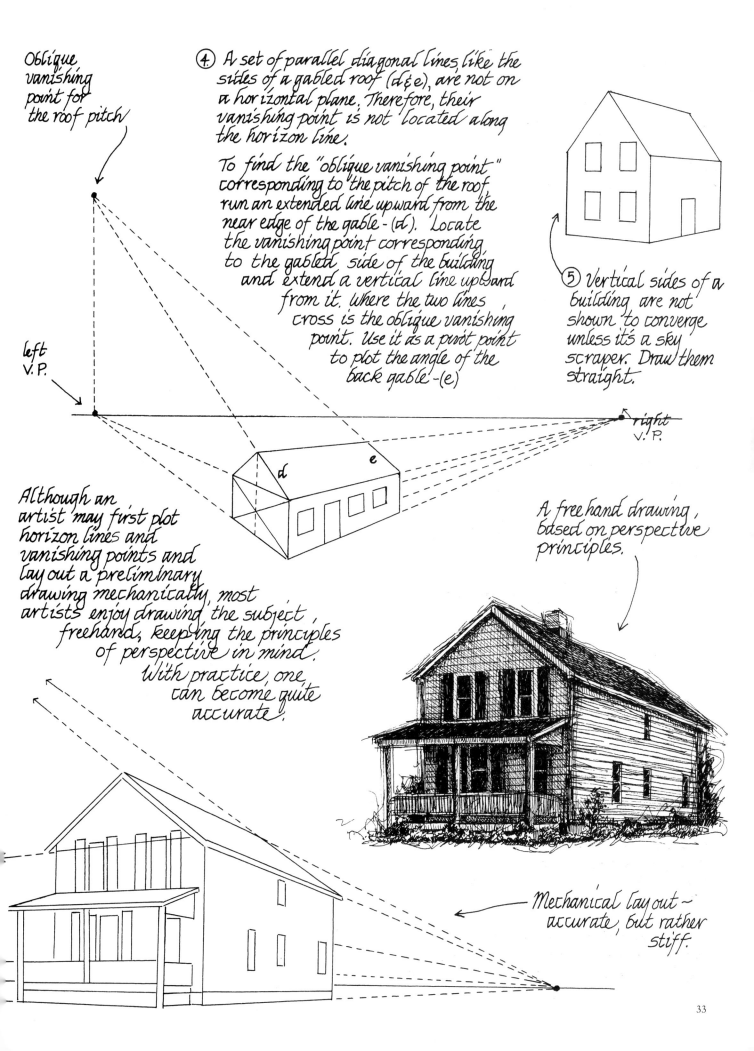

Working With Perspective

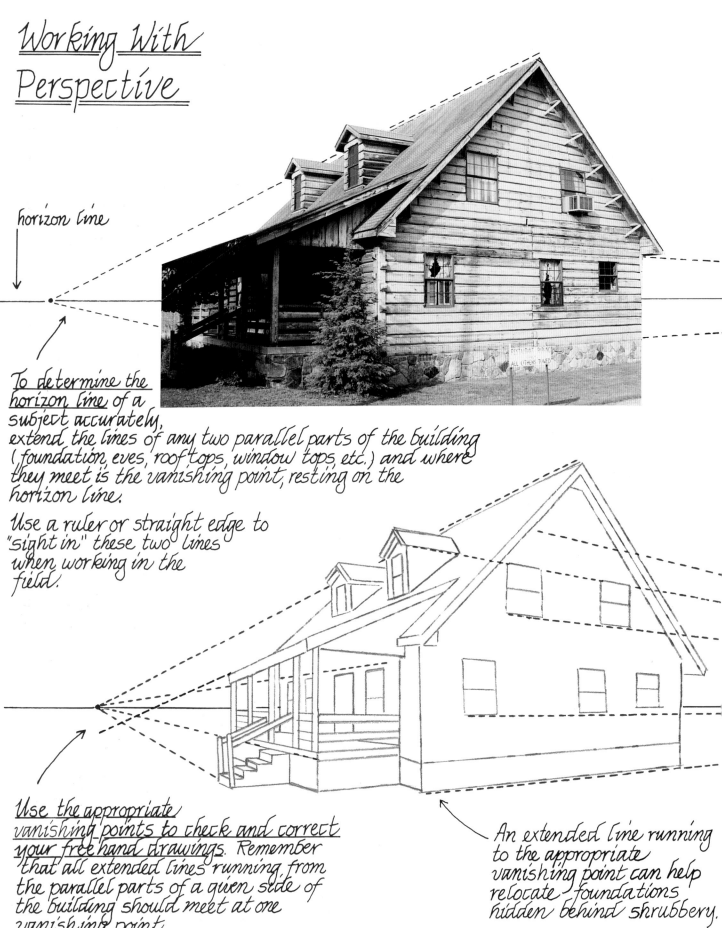

horizon line

__To determine the horizon line__ of a subject accurately, extend the lines of any two parallel parts of the building (foundation, eves, rooftops, window tops, etc.) and where they meet is the vanishing point, resting on the horizon line.

Use a ruler or straight edge to "sight in" these two lines when working in the field.

__Use the appropriate vanishing points to check and correct your free hand drawings.__ Remember that all extended lines running from the parallel parts of a given side of the building should meet at one vanishing point.

Note: The porch roof line (blue) does not merge and should be corrected.

An extended line running to the appropriate vanishing point can help relocate foundations hidden behind shrubbery.

Knowing the position of the horizon line is important when combining two or more buildings from different sources into one composition.

Note how the siding boards on both buildings appear to be almost horizontal at the horizon line level. This is a quick way of approximating the horizon.

Use an established vanishing point as a pivot point for a ruler or straight edge to determine accurate angles for windows, gables, siding boards, porch rails, etc.

A vanishing point can be used to obtain equal spacing in receding fence posts.

Establish the first post (A).

Select a vanishing point and draw three lines to it, running from the top, middle and bottom of post (A), shown in blue. Establish a second post (B) using the vanishing point guide lines.

Determine the spacing for a third post (C) by running a diagonal line from the top of post (A) through the middle of post (B) and downward. Where the diagonal line and the bottom (blue) line cross is the placement for post (C).

Drawing The Subject

A few quick thumbnail sketches will help determine the best view for your detailed layout.

Consider drawing difficulties, value contrast, composition and general eye appeal, then choose the view you like best.

This view was the easiest to draw and has good value contrast.

However, the one-sided view lacks drama and hides the true size of the house.

This view shows depth and has strong value contrasts. The structure lines are clear and easily understood.

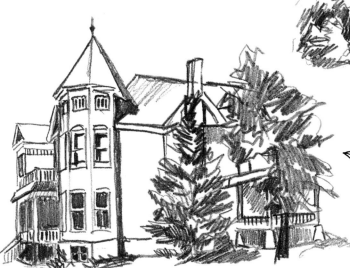

Good composition! My first choice.

Trees hide much of the building, making it hard to draw. The right side is confusing to the eye.

Begin with the basic lines of the structure. Keep pencil work light for easier corrections.

Drawing hint:

Use a clear ruler or straight edge to help see those tricky roof, window and gable angles. Sight in the angle you are trying to draw by holding the ruler up in front of the field subject, or by laying it on the angle of a reference photo.

Without moving the ruler, slip the drawing behind it and check your work.

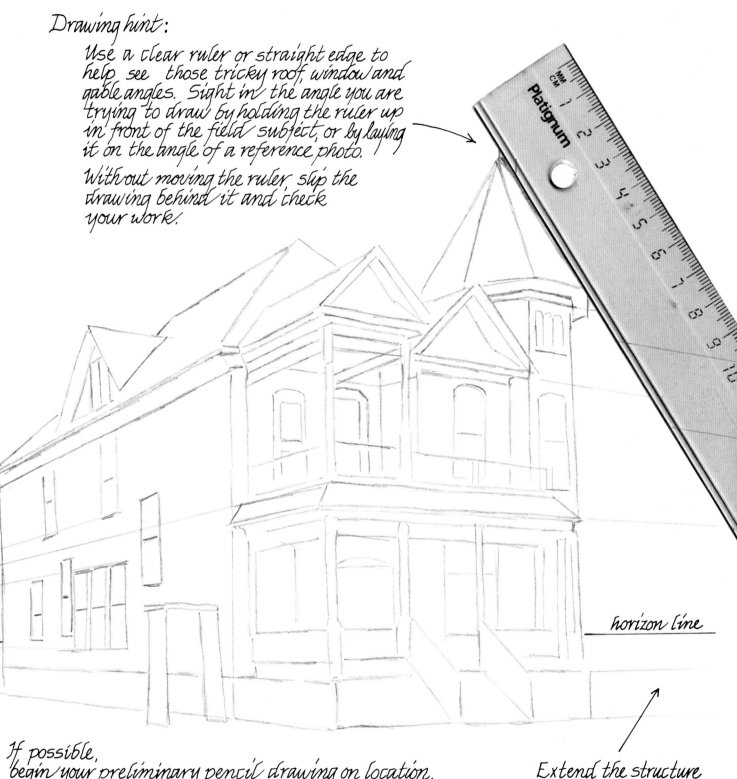

horizon line

If possible, begin your preliminary pencil drawing on location. Use photos and quick sketches as back up visual references. They are especially useful in pin-pointing shadows at a precise time of day.

Time, weather or other circumstances may not permit you to finish in the field.

Extend the structure lines to the horizon and vanishing points, to check perspective.

Make corrections.

Once the main lines of the building are drawn in, checked and corrected, the fun details of the structure can be added. These might include window adornments, "gingerbread," fancy railings, etc.

Add landscaping — the trees, shrubs, flowers and grass that form the building's surroundings.

Unless you're working from a photo, where shadows are stationary, you will need to record the value changes lightly in pencil. Return to field when the lighting on the subject is just right, and mark the shadow areas with light parallel lines.

A

Roof edges often vary in length and angle. (Note roof section A.) Therefore, it's helpful to pencil in a grid to keep the shingles in alignment when they are added later. Simply divide the corresponding roof edges in half, then fourths and eights, if needed. Draw pencil lines between the divisions.

Shadow marks

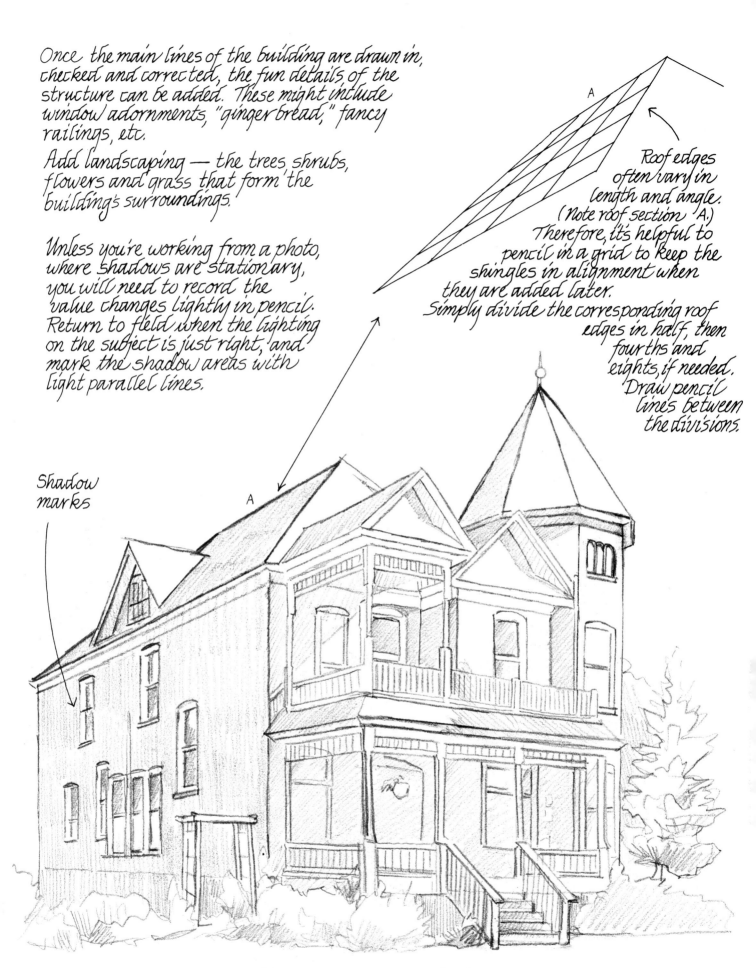

Shrubbery anchors the building to the earth.

With the drawing stage completed,
it's time to bring the subject to
life with an appropriate
medium.

This drawing was finished
in pen and ink using the
stippling technique.
Pen sizes (.25 & .30.)

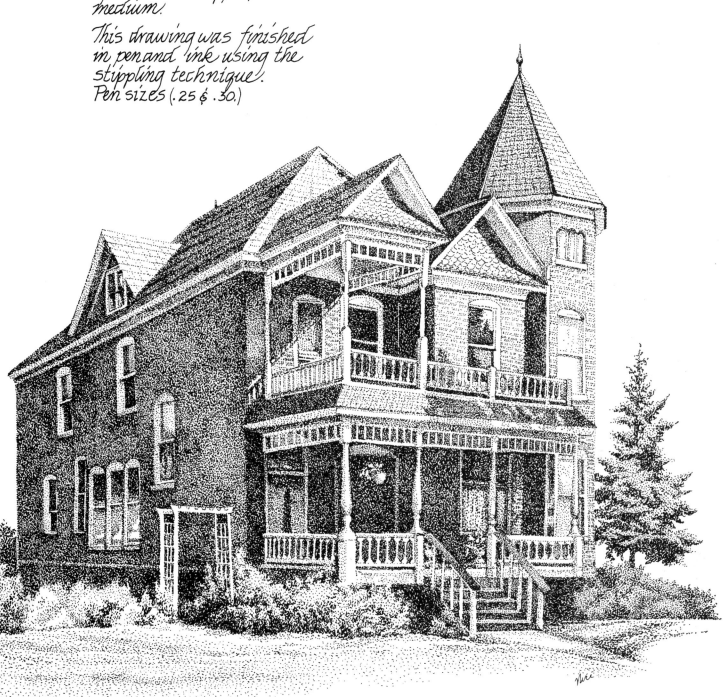

Although tedious, stippling allowed me to
depict the fine details that give this house
its character. Dots help set the mood,
lending an aged, old-photo quality to
this beautiful Victorian.

Creating A Mood

Technique, style, value contrast, color, intensity and the subject matter itself can all affect the mood of the drawing or painting.

Precise, carefully drawn lines shaded with contour, parallel and crosshatched strokes, give the subject a dignified, formal or even elegant appearance.

On the other hand, loose, scribbly lines will lend an informal, whimsical or dilapidated look to the dwelling.

Because of the strong highlights and sketchy style, this drawing relates a happy, carefree mood.

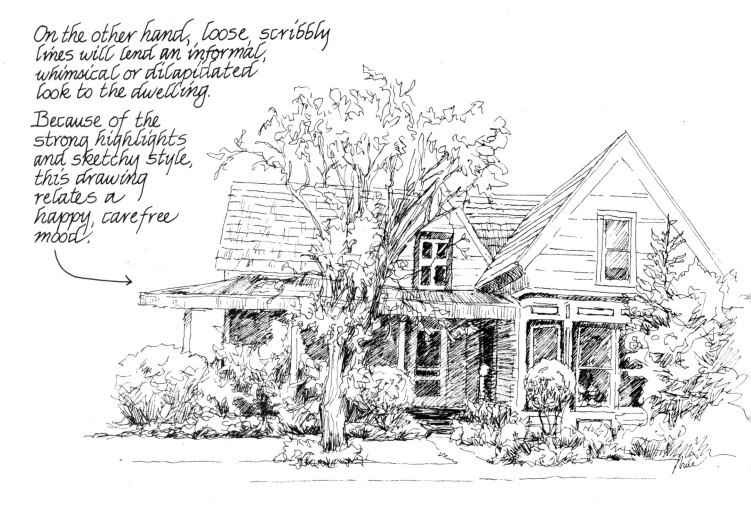

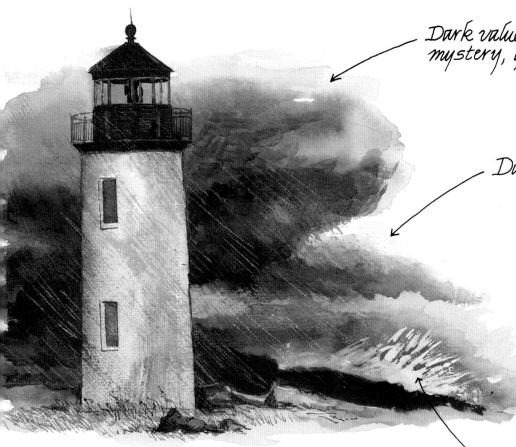

Dark value masses portray mystery, gloom and danger.

Dark, cool colors result in a somber mood.

On the other hand, intense warm colors indicate heat and action.

Spatter fanning outward is explosive and exciting.

Conflicting angles and strong value contrasts suggest drama and action.

If the lighthouse had been left a brighter white, the drama would have been even greater.

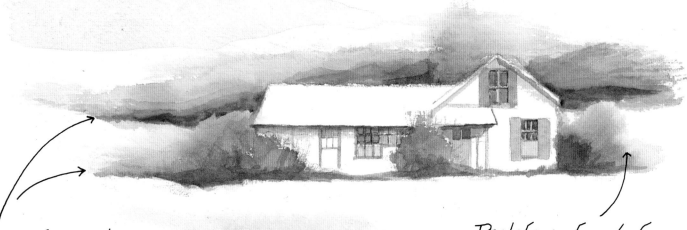

Gently curving, horizontal lines suggest peace and relaxation.

Pastels and muted warm hues portray feelings ranging from restful to cheerful.

41

Composition

The composition is made up of lines, shapes, sizes, values, color, and texture. A good composition is a well thought out arrangement of these elements to catch and hold the interest of the viewer.

Although there are few absolute rules in art, here are some basic guidelines that will help you design better landscapes.

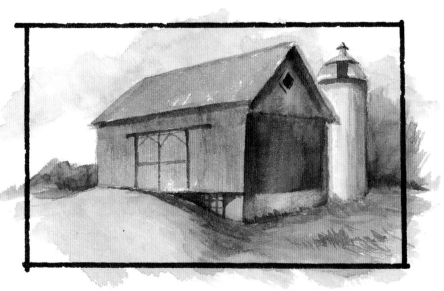

Avoid placing your main subject dead center. This arrangement tends to be static and boring. However, if centrally placed buildings are a must, offset them by grouping another object or two on one side, like the silo in the scene above.

A variety of shapes, both positive and negative, will add interest to the composition.

Objects should not be lined up in a horizontal row, nor spread evenly apart. Form groupings that overlap one another to add depth to the scene. Note the mining camp sketch above.

Strive for a slightly uneven, natural balance in your composition. Think in terms of odd numbers; they are easier to arrange in a natural manner.

Beware of distraction booby traps that hold the eye in one place or send it exiting from the boundaries of the composition. There are several shown in the illustration below.

The composition is unbalanced. All the subjects are crowded on the right side, leaving this area bare and boring.

Strong horizontal, vertical or diagonal lines that lead off the edge will take the eye with them. Soften them, mute them, block them with other lines or remove them if they serve no purpose.

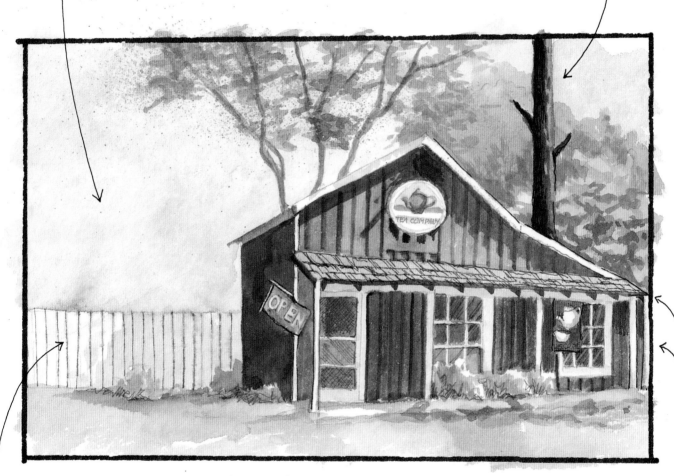

The unbroken, horizontal line of the fence leads the eye off the left edge.

A bright spot of color that stands alone will certainly call attention to itself. Note the red welcome flag.

Repeat strong values and striking colors (or a color variant) in at least three places. This provides harmony in the composition and gives the eye a pathway to follow.

The kiss of death, where an object just touches the edge of the picture.

(In this case, it's the edge of the building. Very distracting.)

Sketching In The Field

The first decision after arriving on location is what to sketch!

Zero in on the subject that most interests you. If the whole building is overwhelming, do a close-up of just part of it— a window, a wall, a bit of gingerbread, etc. <u>Avoid the temptation to draw everything you see!</u>

A few thumbnail quick sketches will help you limber up your drawing skills and decide which subject and view you like.

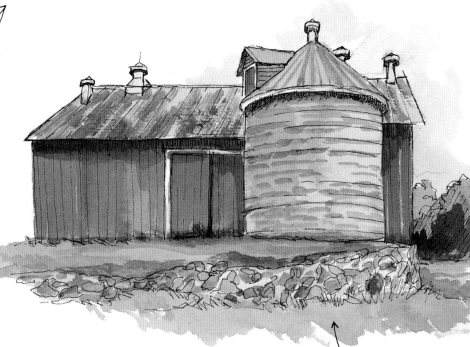

field quick study (pen and ink with watercolor wash).

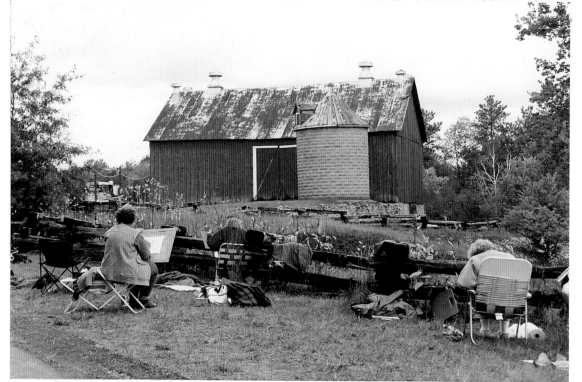

Sketch class in the field; Rhinelander, Wisconsin.

Retain your welcome. Remember to clean up at the end of the day, leaving the location better than you found it.

If your subject is located on private land, don't forget to ask permission to be there. Most land owners don't mind, and may even provide some colorful history about the building you're planning to paint.

Time is a factor to consider when working outdoors in natural lighting. Shadows change quickly or, worse, disappear altogether. Note them right away in your preliminary pencil sketch.

If you're planning a project that will take longer than an hour, taking reference photos at the beginning is a good idea. That way your artwork can be finished at a later date if your work is interrupted in the field.

Don't rely on your memory to furnish details!

Morning or late afternoon lighting will provide the best shadows and value contrasts for sketching and painting.

Supplies for a field sketch kit ~

- Grumbacher Artist Pens sizes extra fine, fine and medium, or Rapidograph pens sizes (.25) (.35) and (.50), and Koh-I-Noor Universal Black India Ink

- Mechanical pencil or no. 2 pencil with sharpener, and a white vinyl eraser.

- A small bound sketch journal, a water-color paper block or a sketch pad.

- A 6-to 12-inch clear plastic ruler for sighting in the subject.

- A small plastic water container for washes and clean up.

- A few paper towels or napkins.

- Small plastic watercolor paint box, with the basic palette colors squirted into it. (Old children's paint sets work well for this.)

- A few of your favorite watercolor brushes. I'd leave your Kolinski sables in the studio and select a few of your old reliable brushes.

Weather ~ Plan for it!

Sunlight can be blinding as it reflects off a white work surface. Try to face away from it so you shade your work, or choose a shady location.

Carry drinking water, sunscreen lotion, bug repellent and a small first-aid kit. Wear a wide brimmed hat. A folding chair will add to your comfort.

In rain and wind you will need some kind of shelter. I've sketched from cars, cabin porches, tents and even under make shift tarp covers. Umbrellas may work in a pinch, if they are big enough.

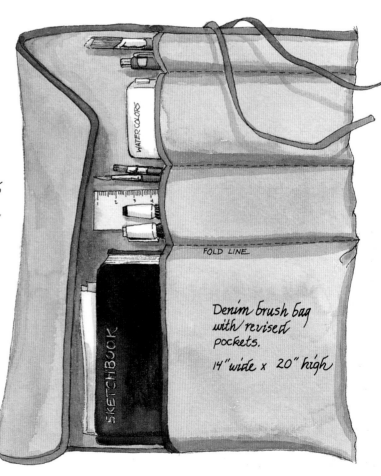

Denim brush bag with revised pockets.

14" wide x 20" high

Most of these supplies should fit nicely in a fanny pack, camera case, tote bag or revised brush bag. Keep it light and easy to carry.

Working From Photos

If you can't work on location, drawing from quality photos or slides is the next best thing. However, don't become a slave to the photograph. Use your artistic license to make changes.

- Eliminate distractions, clutter and objects that date the scene, unless the painting is meant to depict a certain period.

- Mute, intensify or change color as needed.

- Strengthen weak shadows and highlights to create good value contrasts.

- Rearrange the scene to improve the composition.

- Add objects or combine several photos, keeping unified lighting and perspective in mind.

When possible, take your own photos so that you will hold the copyright to your reference material. Controlling the camera will allow you to choose the views that are most artistically appealing.

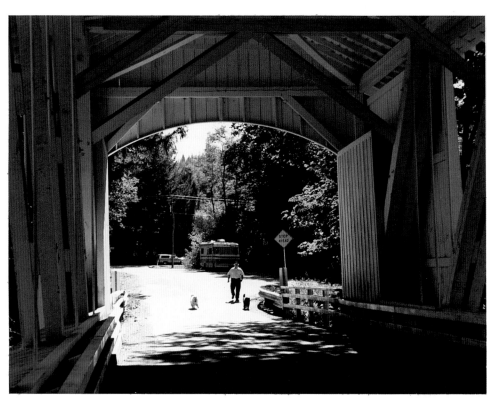

To improve the covered bridge scene above, I would remove the vehicles, power pole and stop sign and dip the sky a little further into the trees. The man and dogs add interest. I would leave them.

The telephone pole and the background clutter on the left need to be eliminated from this scene. The foreground is too flat and horizontal. I would add a bit of interest on the right-hand side. Some cloud shapes in the sky would be nice.

According to the laws of perspective, vertical walls, viewed from ground level, seem to converge inward as they recede toward a vanishing point overhead.

As seen in these two photos, the camera lens is very good at capturing this.

Unless the building is _very tall_, walls that lean inward seem strange to the eye.

To avoid having your building resemble a house of cards ready to collapse, straighten those vertical walls to 90°.

Vertical window edges, door frames, support pillars, etc., may also need to be adjusted.

Rapidograph Pens (.18, .25 & .35)

walls were straightened →

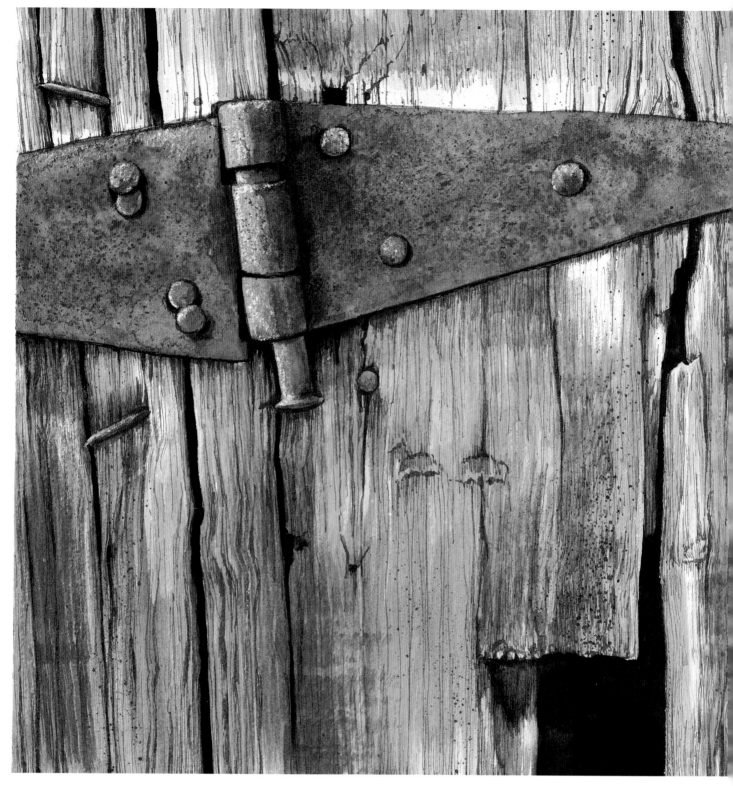

BARNWOOD, 8″ × 10″ (20cm × 25cm)
Watercolor textured with impressed sand, spatter and gray pen work.

WEATHERED WOOD AND RUSTING IRON

Have you ever really looked at old wrinkled faces? I find them fascinating. I like the way the sunlight adds a bit of sparkle to tired old eyes and plays across the contours of age-folded features. There's a mystery there, in the patriarchal face, that speaks of a bygone day and stories we have yet to hear. Old weathered wood is like that—gray and checked and worn with age. Each crack and splintered edge is a reminder of years gone by and storms endured. Like an old familiar face, aged wooden walls are somehow comforting. People are drawn to them as if to renew an old acquaintance. It's no wonder that artists are so fond of barn wood and dilapidated dwellings as subject matter. But to capture the nostalgia in addition to the shape makes all the difference in the success of the project. Bent, rusty nails; crusty iron latches; protruding knotholes; and sagging lichen-covered shingles all add to the mood of the story.

In this chapter, I'll show you how to create that weathered look in wood and iron. Practice a little, then take a drive in the country. There are lots of friendly old relics out there just waiting to be discovered and sketched.

Weatherworn Wooden Siding

Seen close up, weathered boards or barn wood make a highly textured, muted background for still life objects, florals and portraits.

① Start with a light pencil sketch and a pale, varied wash of muted earth tones. Let dry.

Wood colors vary. Here I've used Yellow Ochre, Payne's Gray and Sepia washes.

② Use a ¼- to ½-inch flat brush with the hairs fanned out slightly, to drybrush in wood grain lines.

Use a medium dark wash of Burnt Umber / Payne's Gray or Sepia / Indigo, mixed to complement your chosen wood color.

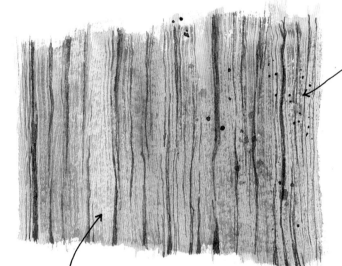

spatter

③ Finish with wavy line pen work, using Gray, Sepia or Black India Ink. (.18, .25 or .30)

Stroking the pen lines immediately with a moist brush will soften the look of the grain lines.

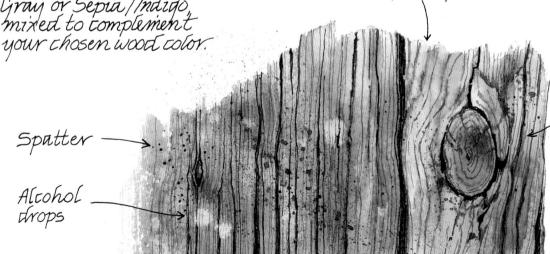

Spatter

Alcohol drops

A knothole makes a great focus point.

Seen at a distance, color becomes the most important factor in portraying raw, weathered siding.

Wood grays as it ages, taking on the neutral gray and brown tones shown here. ⟶

Neutral Gray- (mix of any two complementary colors)

Sepia Brown

Burnt Umber/ Payne's Gray

Burnt Sienna/ Ultramarine Blue

Sepia/ Indigo

① Lay down a pale, warm undercoat wash of Burnt Sienna/Yellow Ochre. Let dry.

② Glaze the base-coat with one or more of the neutral gray colors. Add as many layers as needed to define shapes and shadows.

Use some subtle drybrush texturing to suggest wood-grain direction.

Finish with Gray or Sepia pen work to deepen shadows and define cracks between boards. Keep ink lines soft by working on a moistened surface and allowing lines to fray out.

Drybrush

Scribbly Crosshatch (Sepia .25)

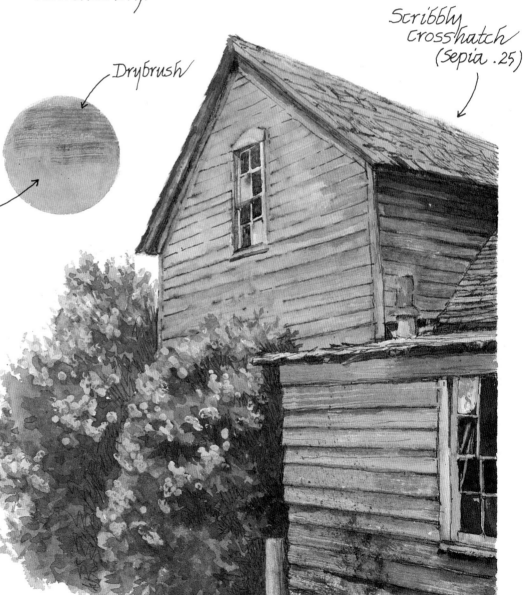

51

Aged Wooden Shakes

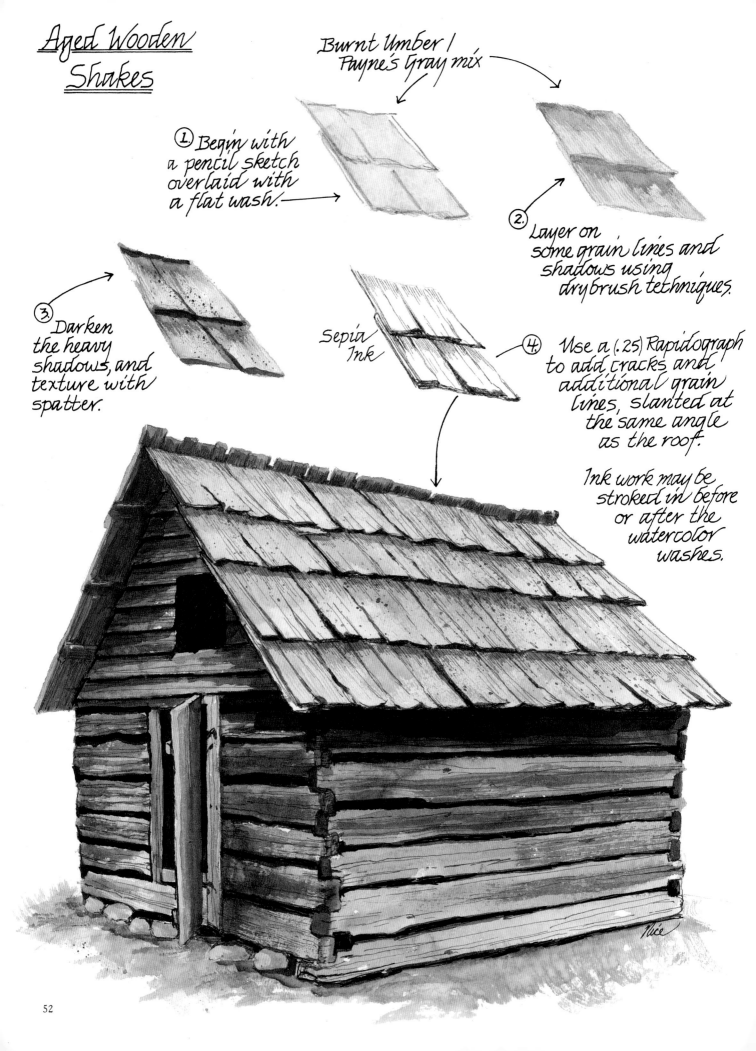

Burnt Umber /
Payne's Gray mix

① Begin with a pencil sketch overlaid with a flat wash.

② Layer on some grain lines and shadows using drybrush techniques.

③ Darken the heavy shadows, and texture with spatter.

Sepia Ink

④ Use a (.25) Rapidograph to add cracks and additional grain lines, slanted at the same angle as the roof.

Ink work may be stroked in before or after the watercolor washes.

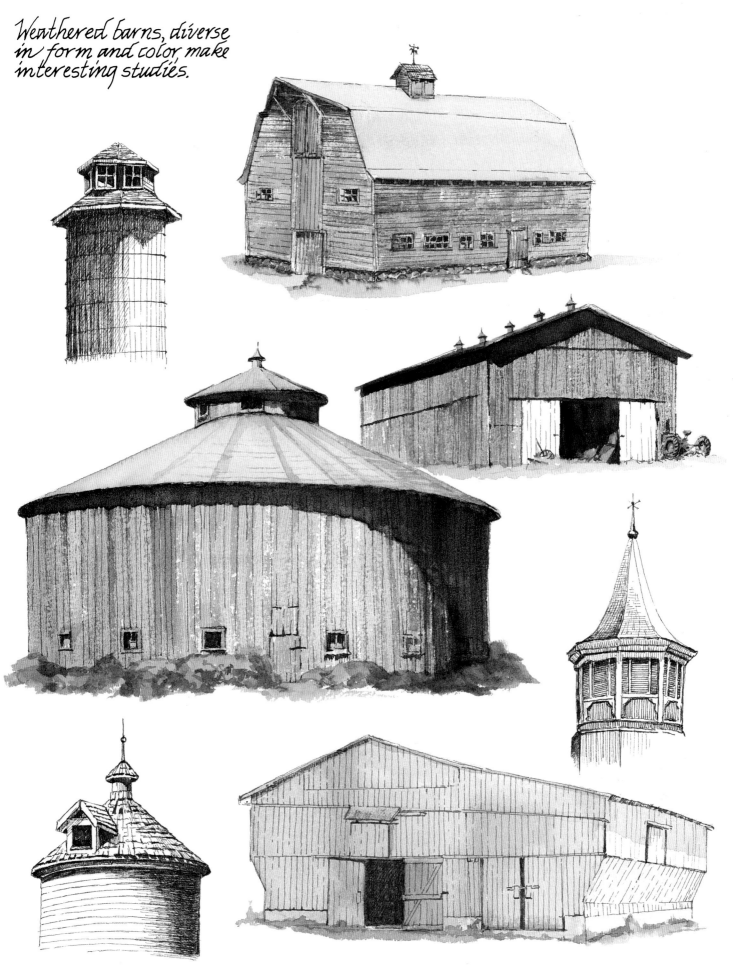

Weathered barns, diverse in form and color, make interesting studies.

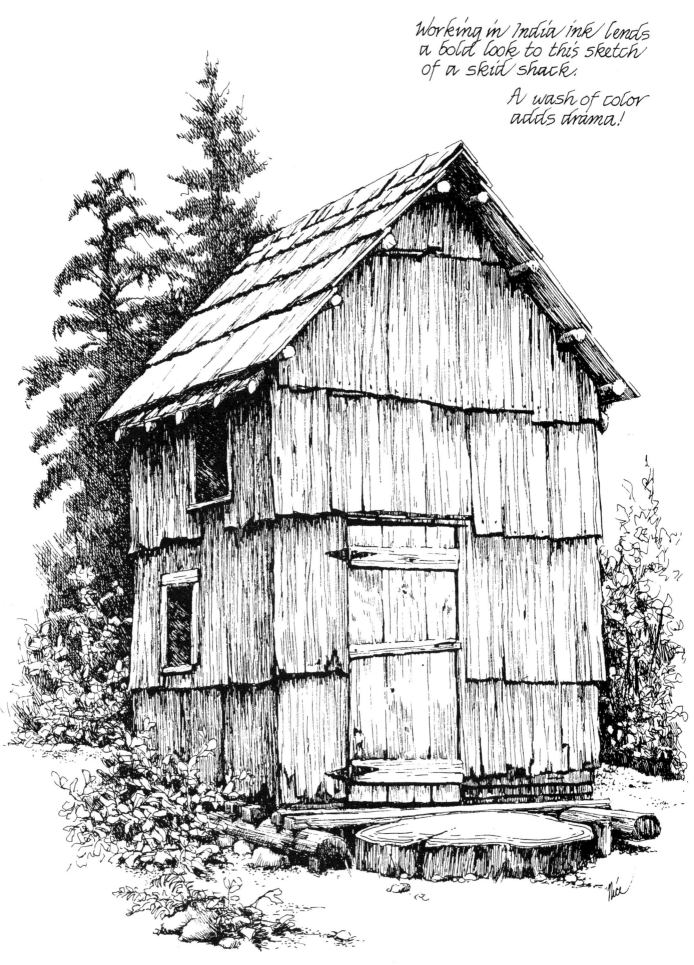

Working in India ink lends a bold look to this sketch of a skid shack.

A wash of color adds drama!

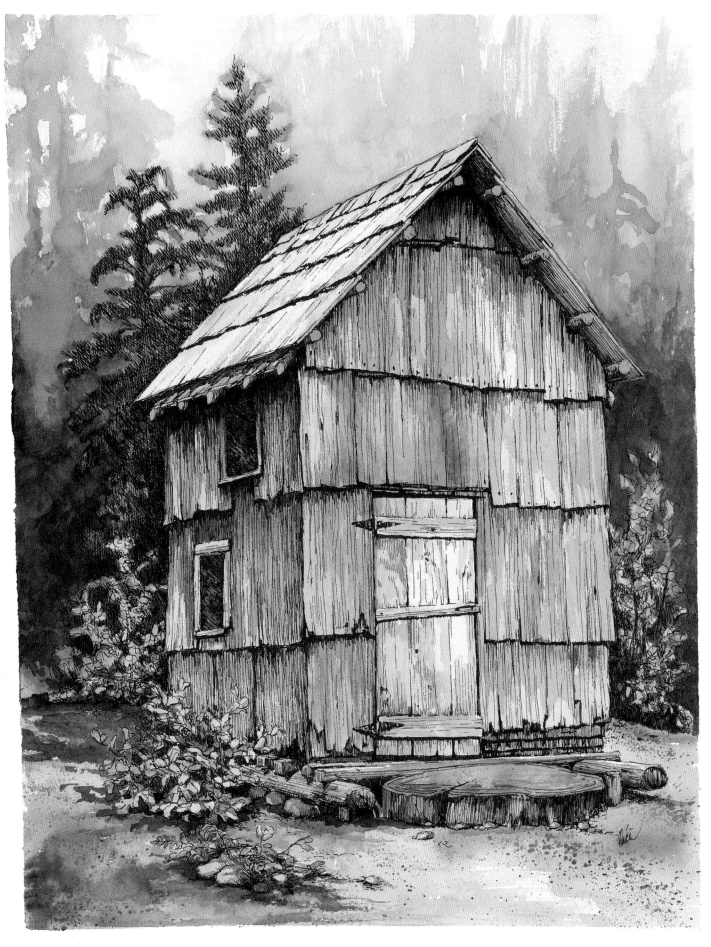

SKIDSHACK, 10″×8″ (25cm×20cm)
Pen, ink and watercolor.

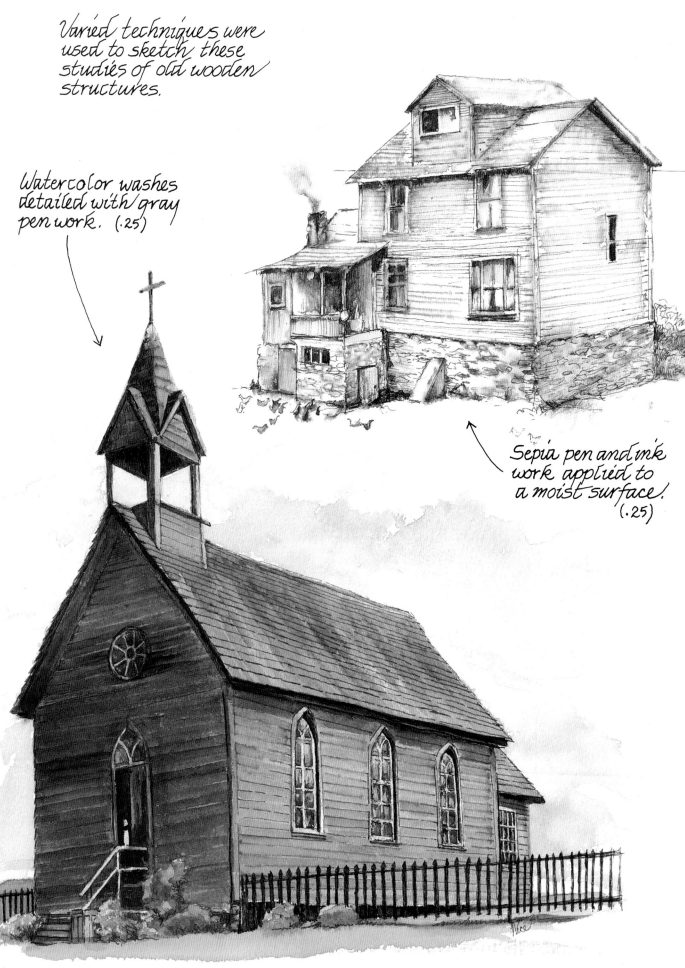

Varied techniques were used to sketch these studies of old wooden structures.

Watercolor washes detailed with gray pen work. (.25)

Sepia pen and ink work applied to a moist surface. (.25)

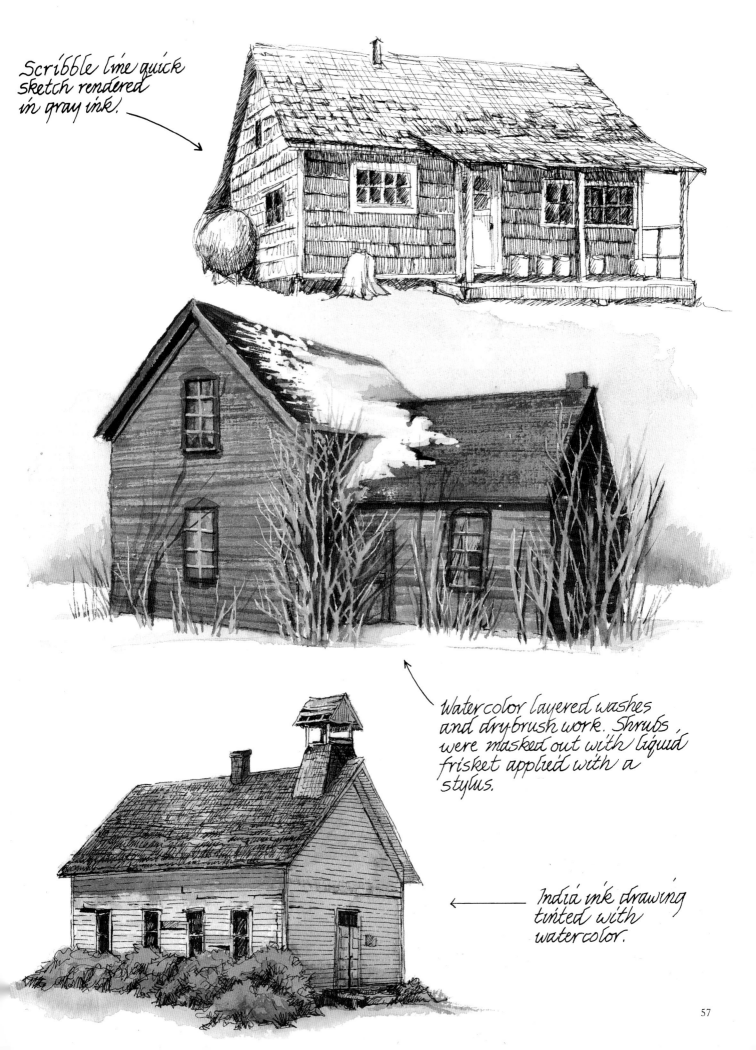

Scribble line quick sketch rendered in gray ink.

Watercolor layered washes and dry-brush work. Shrubs were masked out with liquid frisket applied with a stylus.

India ink drawing tinted with watercolor.

Log Structures

Log structures are portrayed using techniques similar to buildings with raw wooden siding. However, the shape of hand-hewn logs can be quite irregular, and the space between the logs is often light due to a pale chinking mixture.

① Begin with a warm base wash of Ochres and Siennas.

② Use layered dry-brushing to add shape, shadow and texture.

③ Add final details, grain lines and heavy shadows with Sepia ink over a moist surface. (.25)

Neutral Gray wash

In the east, logs were usually hewn to be flat sided.

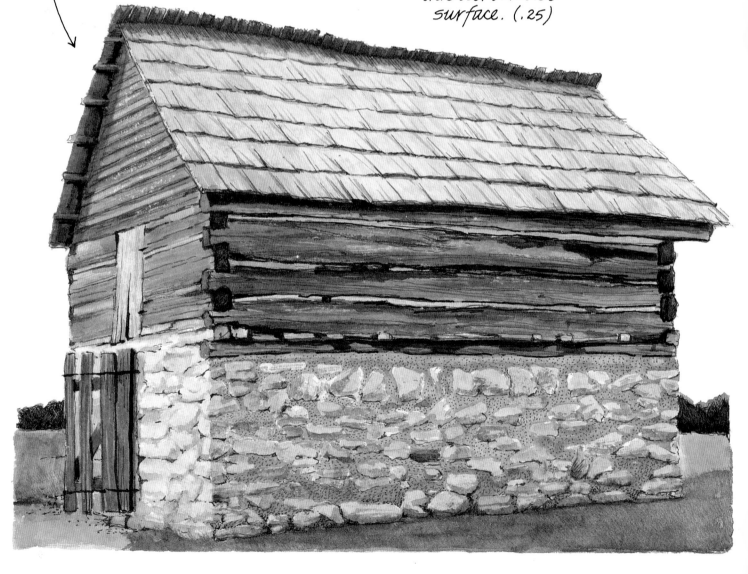

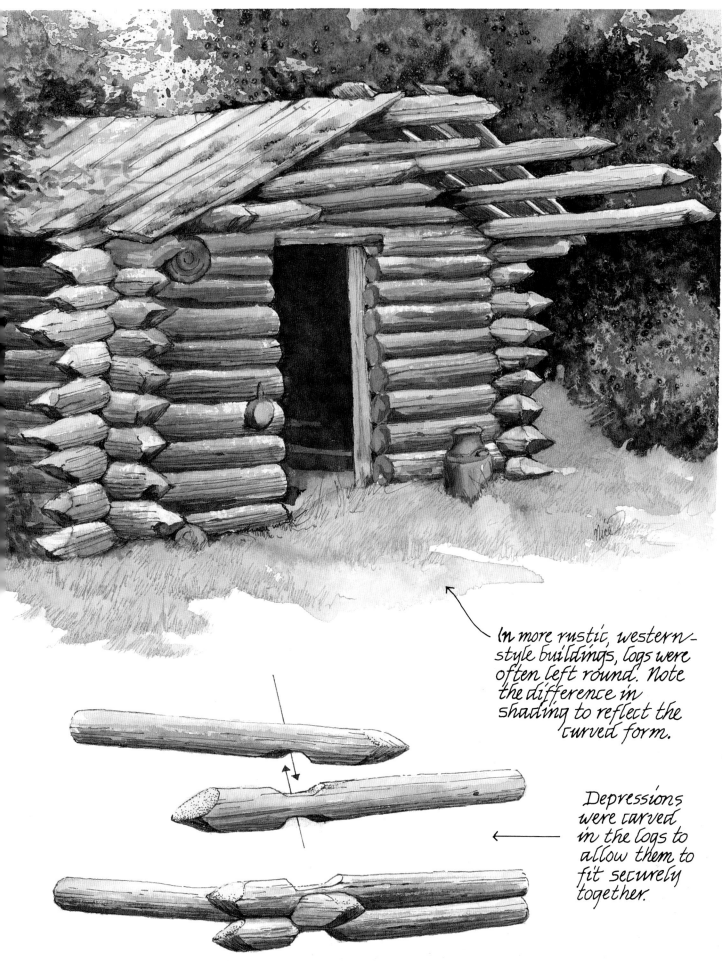

In more rustic, western-style buildings, logs were often left round. Note the difference in shading to reflect the curved form.

Depressions were carved in the logs to allow them to fit securely together.

These log cabin studies were sketched from buildings seen while traveling through the Smoky Mountains.

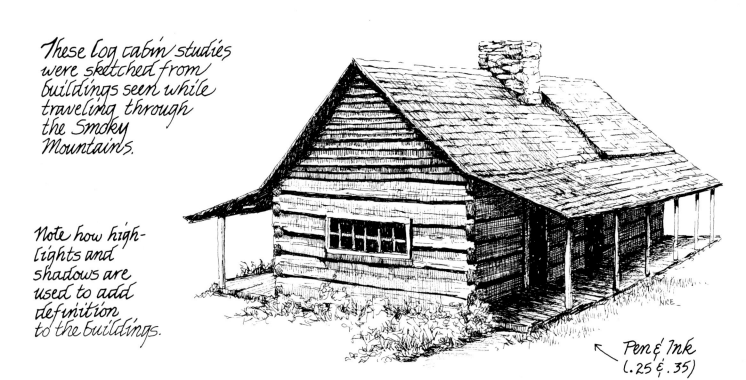

Pen & Ink
(.25 & .35)

Note how highlights and shadows are used to add definition to the buildings.

Sponging

Bruising

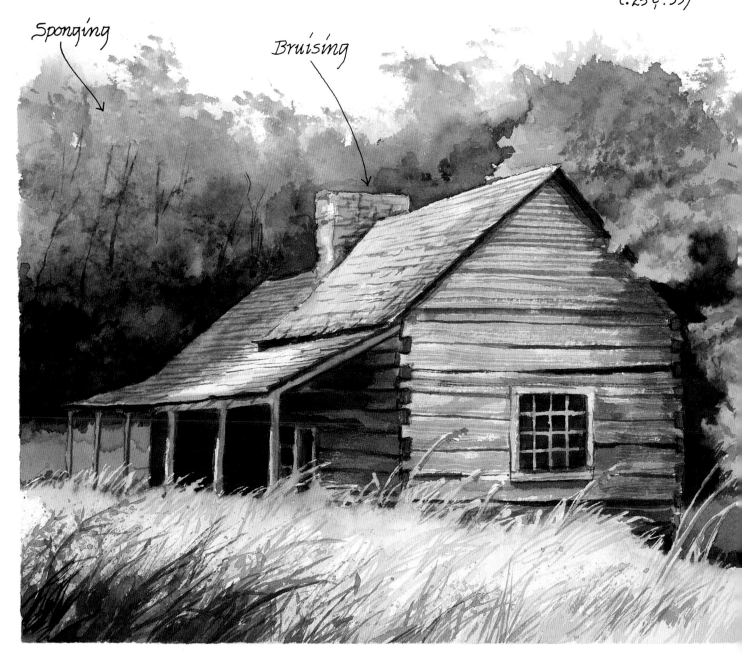

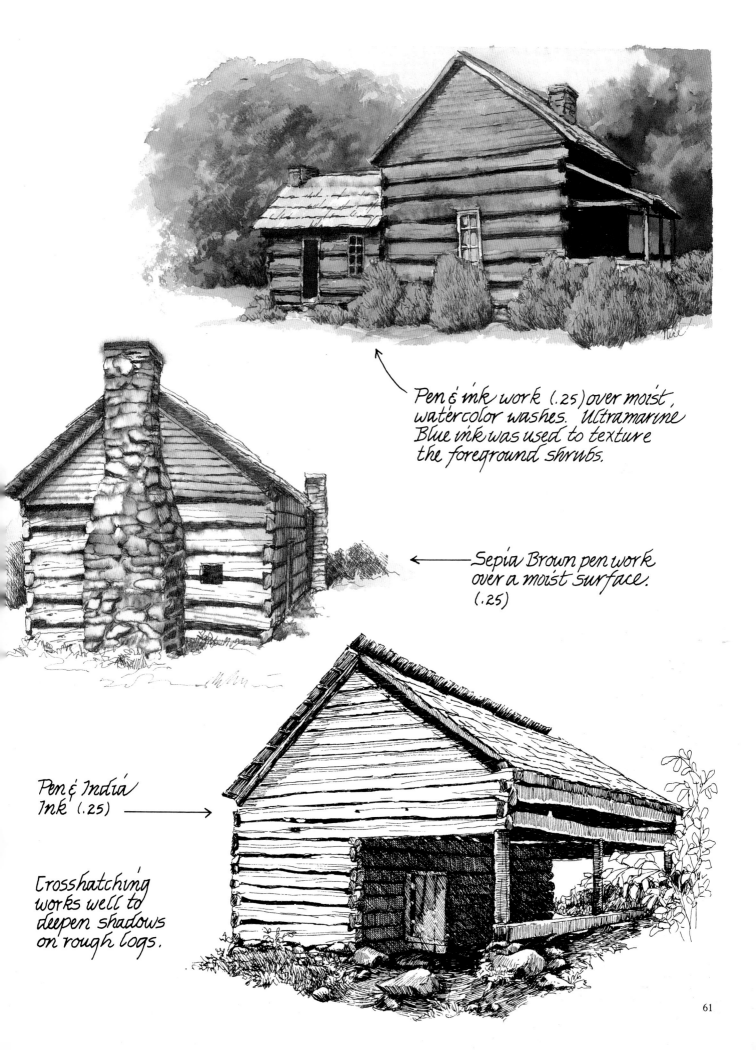

Pen & ink work (.25) over moist watercolor washes. Ultramarine Blue ink was used to texture the foreground shrubs.

Sepia Brown pen work over a moist surface. (.25)

Pen & India Ink (.25)

Crosshatching works well to deepen shadows on rough logs.

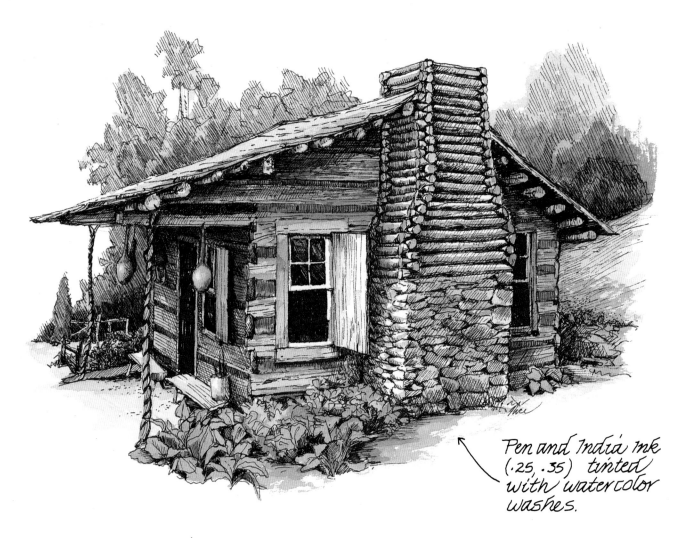

Pen and India ink (.25, .35) tinted with watercolor washes.

The red clay soil found in the South-east adds wonderful color to log buildings. It was used to chink (fill) the spaces between the logs, and, with time, added an orange stain to the logs themselves.

Below are the clay colors I used.

Orange/Burnt Sienna

more Thio Violet added

Orange/Burnt Sienna and a hint of Thio Violet

Orange/Burnt Sienna/ Thio Violet and Ultramarine Blue.

The cabin shown here and on the opposite page was photographed in the rugged Cherokee Lands of North Carolina. Note how distance changes the focus of the resulting compositions.

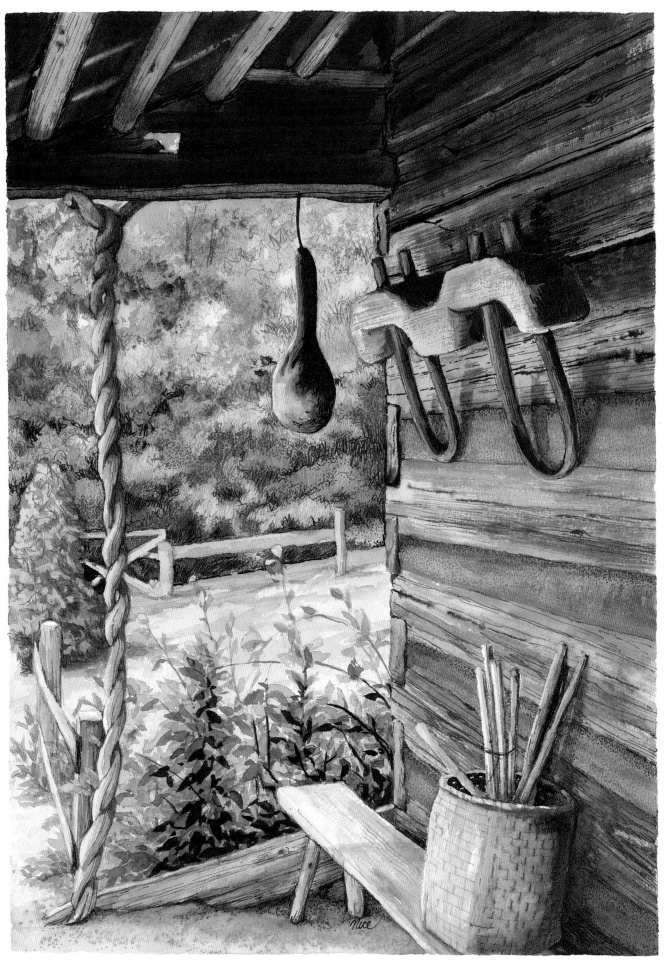

CHEROKEE CABIN, 10″×8″ (25cm×20cm)
Watercolor enhanced with pen and colored ink.

Rust

Seen up close, rust has a dusty or gritty appearance best portrayed by impressed sand, spatter or stippling techniques.

Mottled wash with impressed sand and water spatter.

Spatter over a mottled wash.

Mottled wash with pen stippling (Sienna, Sepia and Blue ink).

Choose colors ranging from earthy oranges, ochres and sienna's to maroons and muted violets. Don't forget to add a touch of local metal color here and there.

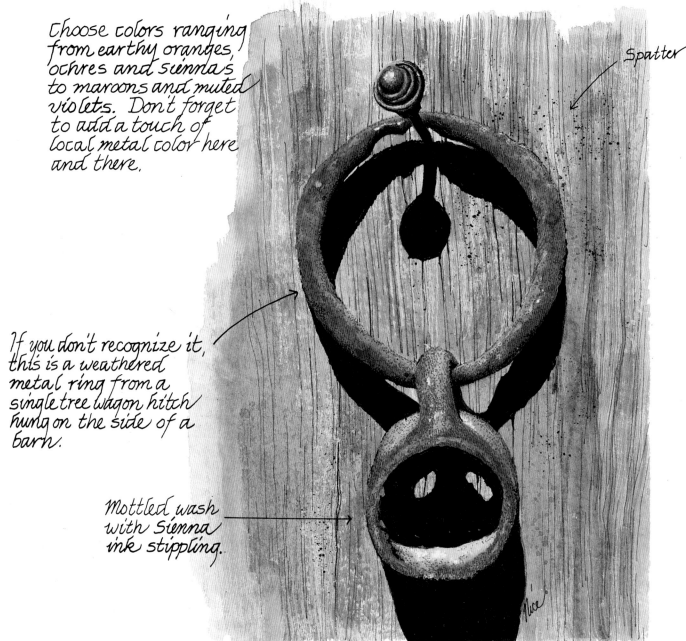

Spatter

If you don't recognize it, this is a weathered metal ring from a single tree wagon hitch hung on the side of a barn.

Mottled wash with Sienna ink stippling.

At a distance, the texture of rust is not seen. To depict corroded metal roofs, rely on muted rust tones and blotting, scratching and dry-brush techniques.

On large roof areas, spontaneous wet-on-wet washes can be very effective.

Burnt Sienna and violet (Thio Violet + Ultramarine) muted with yellow-green.

① Begin by base coating the roof with a very pale gray wash. Let dry.

Gray base can be warm, cool or neutral.

② Re-dampen the roof and brush on a muted rust wash. Blot gently with a paper towel to add value variance.

③ Following the pitch of the roof, add some drybrushing and razor-scratched highlights.

Rust tones repeated here.

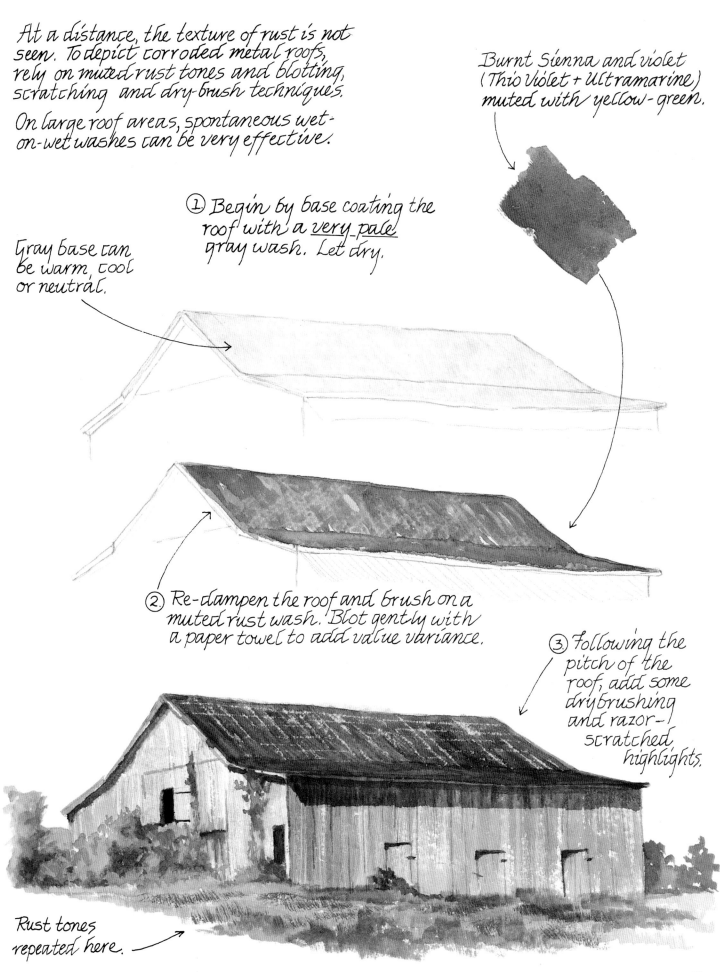

RELICS, 16″ × 20″ (41cm × 51cm)
Watercolor enhanced with pen and colored ink.

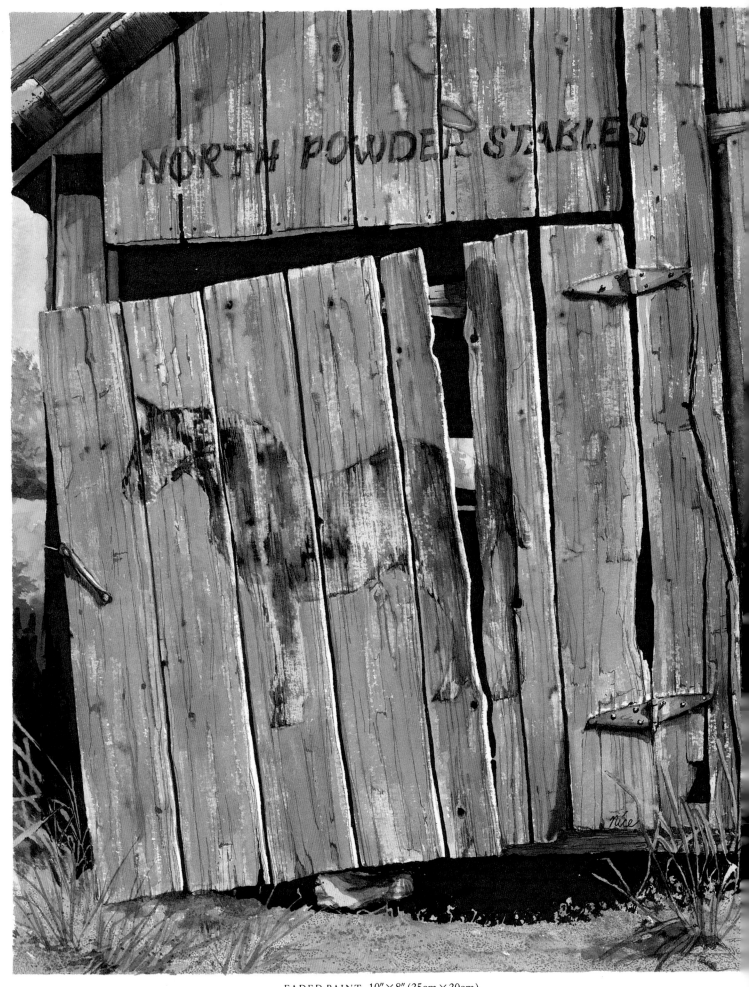

FADED PAINT, 10″×8″ (25cm×20cm)
Watercolor textured with drybrush work and pen and ink.

FADED AND PEELING PAINT

The weather has done its work. The old red barn has faded to a burgundy pink, disappearing altogether here and there to reveal the original wood, clad in dignified gray. The white farmhouse up the road has also mellowed with age. There's a warm patina glazing its white walls. Stains from rain-spattered soil, wind-driven dust, and creeping rust and algae have all left their marks. Along the eaves, curls of white paint have peeled back like wayward locks of hair escaping the confines of a hat. The sight is enough to make the caretaker groan, filling the mind with thoughts of restoration—scraping, priming and repainting. But to the mind of the artist, the color and texture of faded, peeling paint can be a delight. So much so that a whole faux finish industry exists, providing products to make new paint look old, checked and dull. In home furnishing, old is in, and in artistic renderings, the patina of time is definitely more interesting.

This chapter will show you how to depict the look of old paint, how to fade the colors to mellow hues and how to recreate the checks, peels and cracks that add history to the house. For distant buildings, some layered drybrushing will do the trick. For closer studies, only the imagination will limit the ways in which pen, ink and watercolor textural effects can be combined to suggest faded and peeling paint.

Depicting Old Paint

① Begin by masking out areas to represent old paint.

Paint the raw wood areas with varied washes of brown.

② Lay in faded, old paint colors.

Use drybrush techniques to add woodgrain and shadows.

③ Woodgrain detailed with Brown ink & (.25) pen.

Use India ink and (.25) Rapidograph to darken deep cracks.

Ⓐ For old whitewash begin with an off-white wash. While still damp, brush in brown wavy line streaks.

Ⓑ Use a no. 4 round brush to detail woodgrain, holes, cracks and shadows.

Spatter

Ⓒ Use a (.25) pen and light gray or brownish ink to add the fine paint cracks. (Follow direction of woodgrain.)

Darken woodgrain with dark brown, Sepia or India ink.

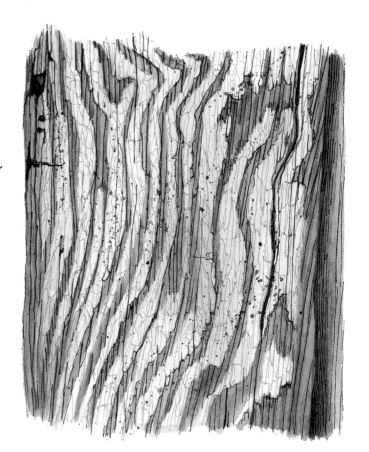

Working larger than life brings out the detail and texture. A flaky section of old painted board takes on an interesting, abstract look!

When chipped raw wood areas are pale and few in number, mask them out, and lay in the more dominant, old paint color first.

This old paint color is a blue-green mix, muted slightly with Burnt Sienna.

Gray ink, over a re-dampened surface, was used to suggest grain and shadows in the raw wood patches.

Blue-green ink and a (.25) pen were used to depict fine cracks in the old paint.

Cracks follow the direction of the wood-grain.

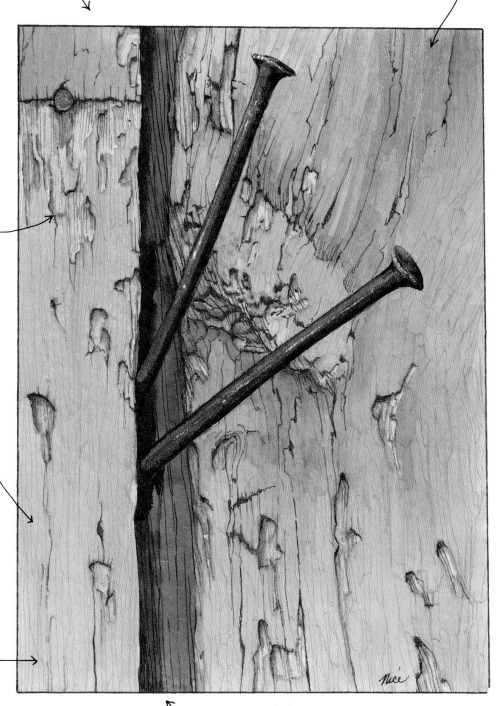

Shadow deepened with Indigo paint.

Weathered Paint At A Distance

As paint ages it loses both brightness and intensity, becoming somewhat dull and pastel. Depicting it is a matter of mixing the right color.

① Begin by mixing a color close to what the original paint hue might have been. (You may have to guess.)

This brick red color is Burnt Sienna, Cadmium Red Lt. and a deep red-violet mix.

② Mute (dull) the color by adding a little of the complementary color, in this case yellow-green.

③ Lighten the color to a pastel shade by adding more water.

(Use step 2 as the shading mixture.)

Areas masked out then tinted lightly to represent patches of peeled paint and grime.

Damp surface spatter suggests dust, flecks of mud, chipped paint, lichen, etc.

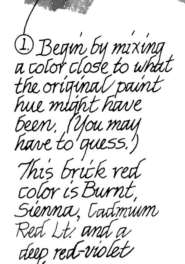

Depict uneven fading and large patches of wear by laying a facial tissue flat upon a moist wash, pat gently and remove.

Although cracks, chips and dirt build up are not visible in great detail, at a distance, the circles at the right show subtle ways to suggest them.

All of these texturing techniques were used in the painting shown on the opposite page.

Cracks and discolored areas can be depicted by layering colored pen work and earth-tone washes over a re-dampened base.

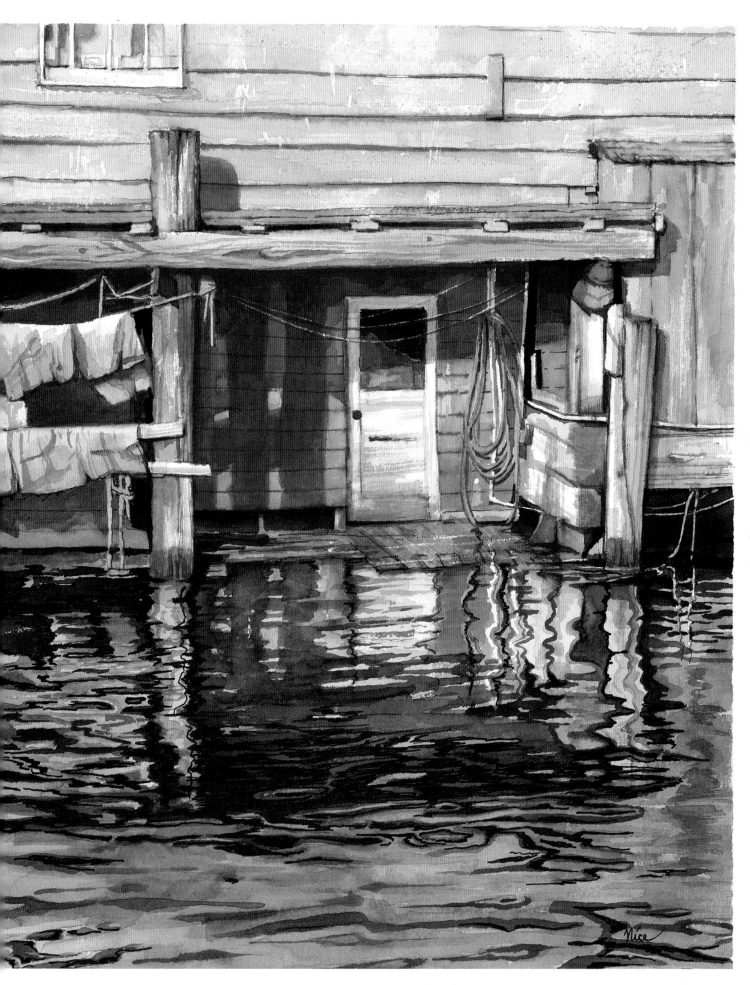

FISHERMAN'S WHARF AT HIGH TIDE, 10″×8″ (25cm×20cm)
Watercolor, pen and colored inks.

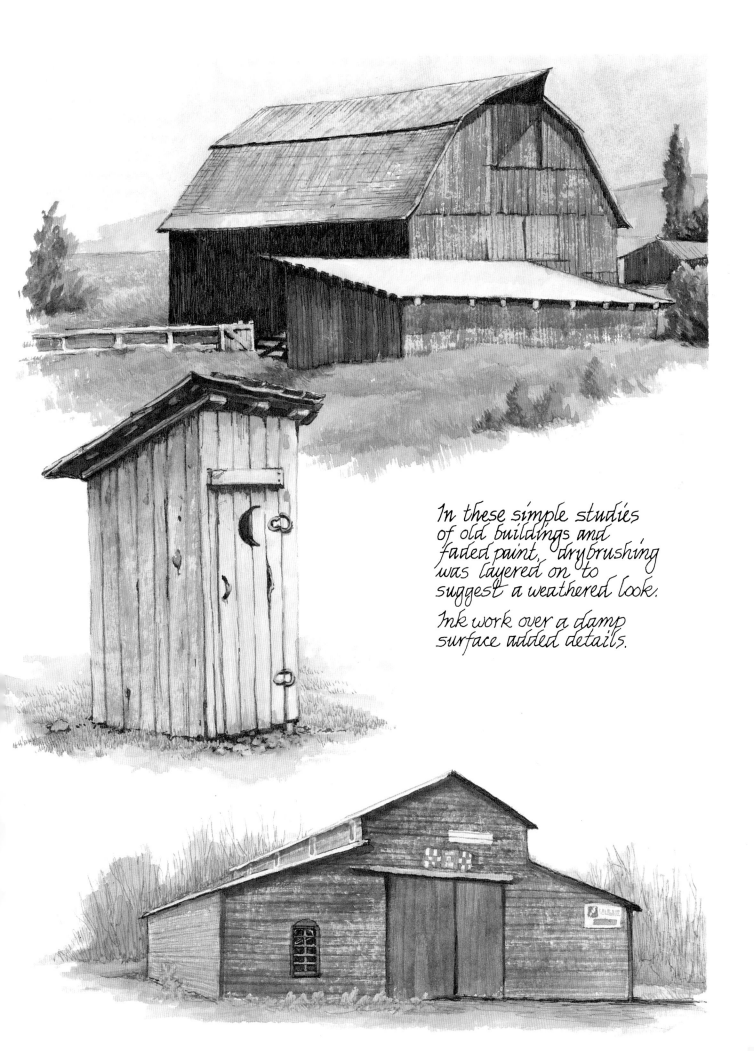

In these simple studies
of old buildings and
faded paint, drybrushing
was layered on to
suggest a weathered look.

Ink work over a damp
surface added details.

White Buildings

White or light-colored buildings take on a special aged patina. Along with the usual cracks, and worn spots, the pale paint readily shows discoloration from dirt, algae and various staining materials.

A combination of drybrush layering, spattering and colored ink work is a good way to depict this.

Use a flat brush to drybrush in a bit of texture and weathered stains. Use earthy browns to add warmth, or neutral or cool gray tones.

①

Use gray ink to define spaces between boards.

Use India ink and a large pen to fill in heavy interior shadows.

②

Add more drybrush work. Use a no. 4 round brush for details.

Maintain unpainted white areas.

Gray ink work (damp surface)

③

Spatter

Olive green drybrush suggests algae.

Layer on a neutral or cool gray wash in shadow areas.

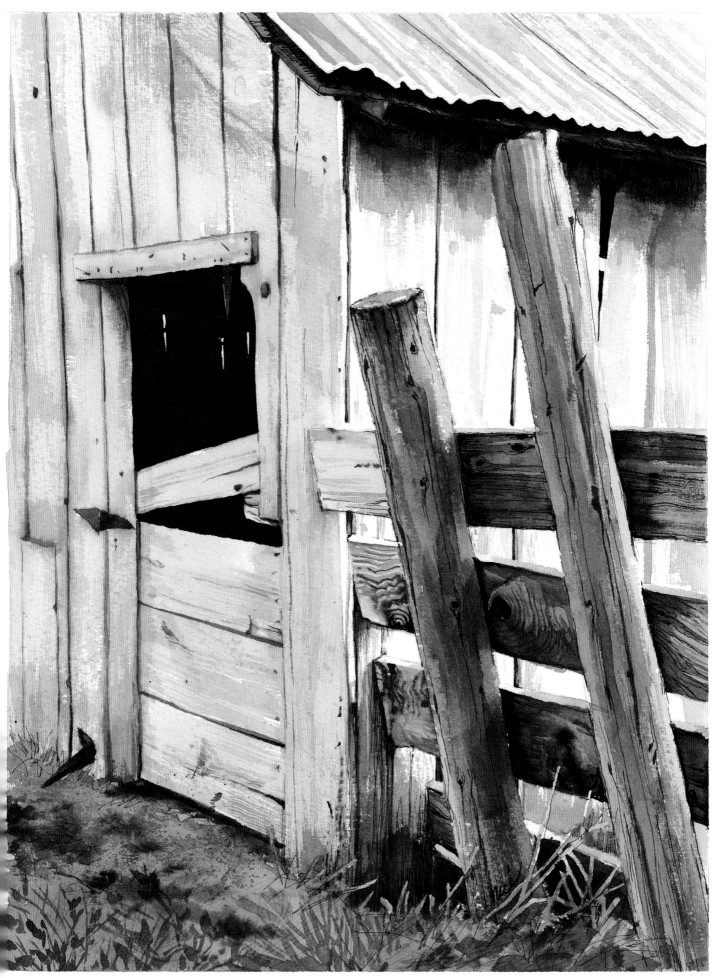

OFF-WHITE BARN, 10″×8″ (25cm×20cm)
Watercolor textured with drybrush work and gray pen and ink detailing.

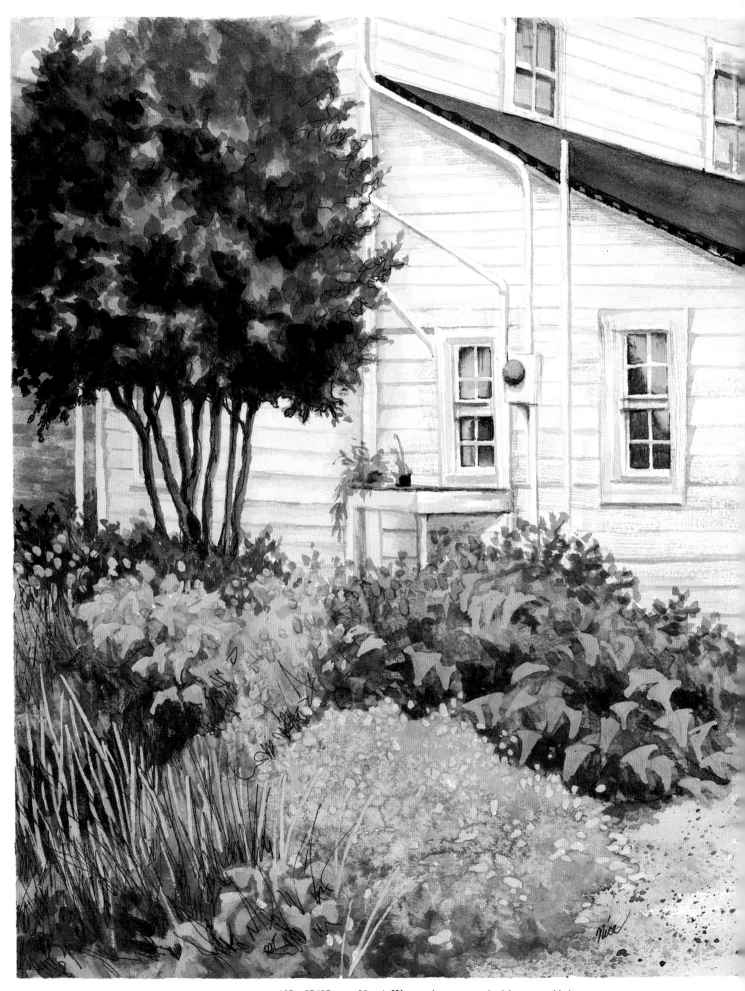

HERB GARDEN, 10″×8″ (25cm×20cm), Watercolor accented with pen and ink.
In this composition, the white walls of an old farmhouse form the background rather than the focus of the painting.
Crumpled plastic wrap, spatter, table salt, masking fluid and penned scribble lines were used to texture the foreground garden.

The white house in the "Herb Garden" painting (opposite page) shows its age. A very pale, off-white base wash depicts the discoloration caused by time and weather. Subtle dry brush texturing suggests that the paint is starting to "check and roughen."

In contrast, the ornate country house sketched below seems to be freshly painted. The use of bright "paper white" highlights and clean blue-gray shadows give it that crisp, snowy appearance.

The edge of a 1/4-inch flat brush was used to add a soft shingle-like texture to the roof.

Complementary colors used on the roof and background add snap to the composition.

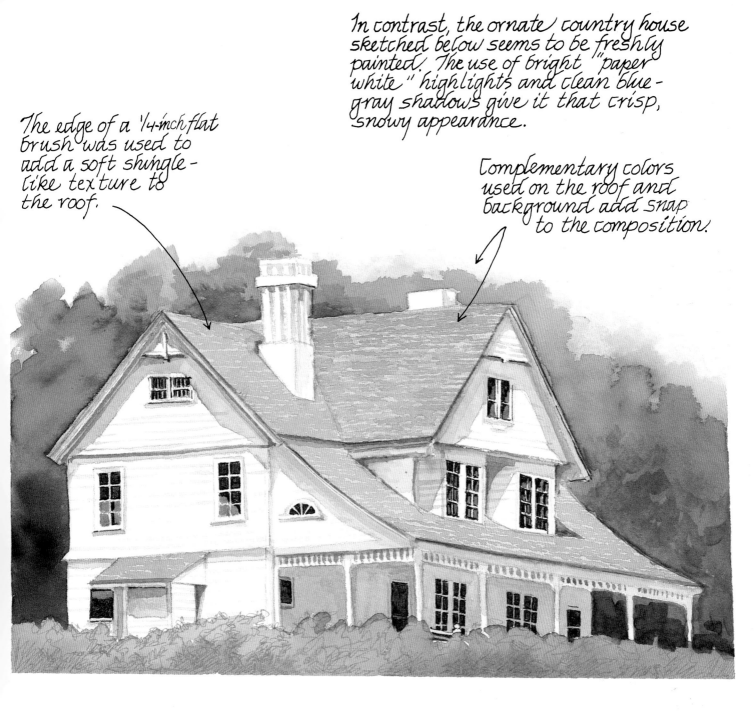

Weathered Paint
In Pen And Ink

Although part of the artistic
appeal of faded, weather-worn
paint is the soft, bleached
coloration, the textures can
be effectively suggested using
just pen and ink.

Crosshatch diagonally
or, for a bolder look
at right angles.

①

the first set of
hatch marks
should go with
the grain of
the wood.

Diagonal
crosshatch

②

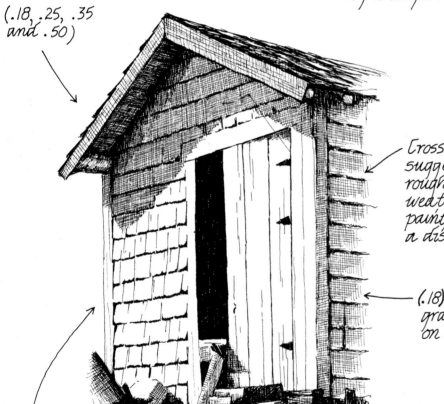

Right-angle crosshatch

(.18, .25, .35
and .50)

Crosshatching
suggests the
roughness of
weathered
paint seen at
a distance.

(.18) Rapido-
graph used
on siding.

Sunlit or smoother painted
surfaces can be depicted,
with a few marks running
parallel to the woodgrain

The eye will see them as cracks or
ridges, reflecting the wood surface
beneath.

Use value changes to
define edges where-
ever possible.

This piece of weathered wood and peeling paint, seen close up, was depicted using a (.25) pen, gray ink and an India ink wash applied with a no. 4 round brush.

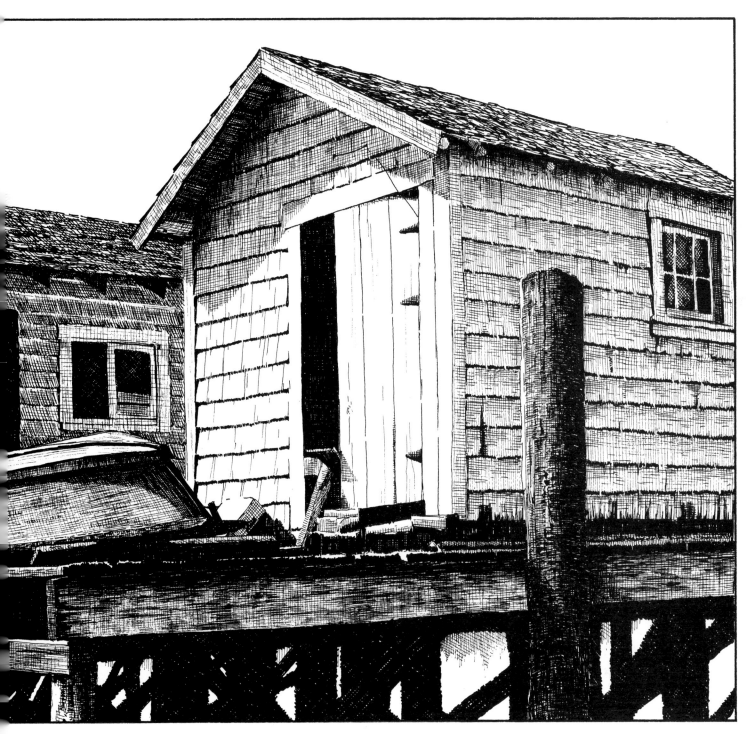

OYSTER HOUSE, 7″ × 9″ (18cm × 23cm)
Pen and ink crosshatching.

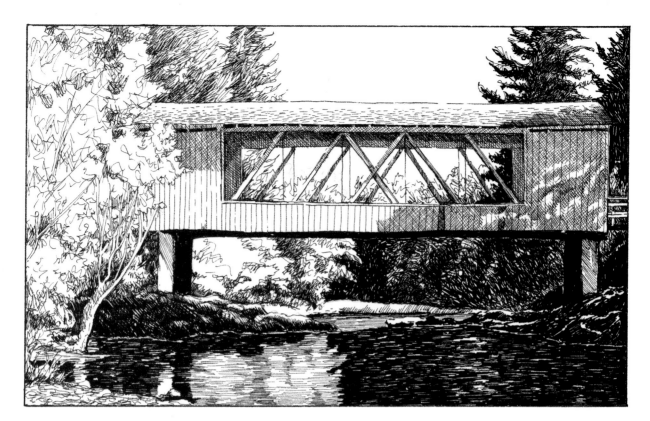

Value and textural contrast add interest, definition and impact to pen and ink drawings. Pen sizes (.18), (.25) and (.35) were used to depict these old buildings. Light strokework suggests that both the bridge and barn were painted a pale color.

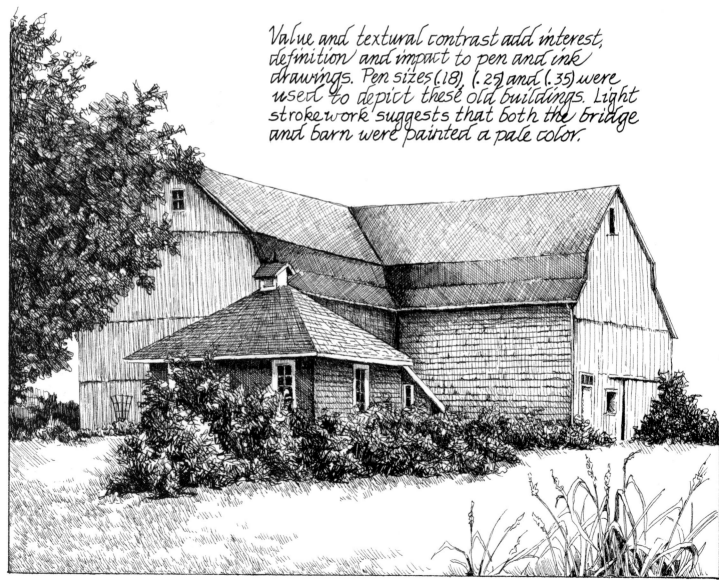

Scribble strokes to suggest shape and shadow.

The essence of an old structure with weathered paint can also be captured effectively using a loose, scribbly style.
A (.30) sized pen nib was used.

Scribbly crosshatch

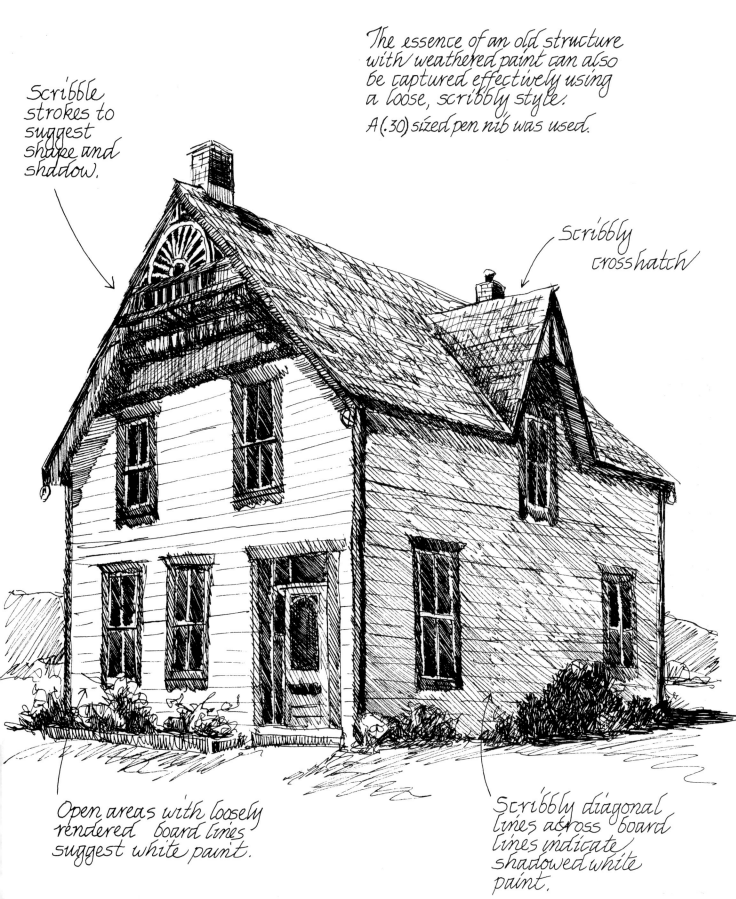

Open areas with loosely rendered board lines suggest white paint.

Scribbly diagonal lines across board lines indicate shadowed white paint.

I found this moldering mansion in
West Virginia and documented it
with both photographs and quick
sketches. The house has an interesting
contour, even with parts missing.
The many varied textures lend
themselves well to pen and ink.

original size of
drawing – 7½" x 10"
(.18, .50)

Although the subject can be
expressed nicely in pen and
ink alone, the mood and
mystery of the house is
greatly enhanced with the
addition of colored washes. ⟶

Blue-green (Viridian), muted with red-orange. — roof area

Red-orange, muted with blue-green. — chimneys

Yellow Ochre, muted with violet. — grass, stonework

Violet, muted with Yellow Ochre. — deep shadows on siding, shrubs, trees

Payne's Gray — used for windows, background hills and siding shadows.

Palette

I tinted the mansion sketch with austere, wintery watercolor washes, to add to the forlorn look.

The solomn hues were produced by combining complementary colors.

The white siding was aged by using Payne's Gray as a base wash in the shadow areas and layering on touches of the other color mixtures.

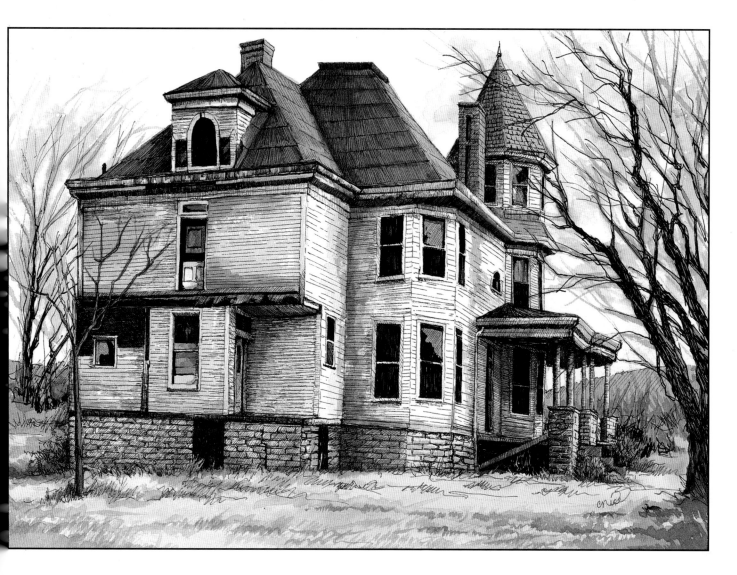

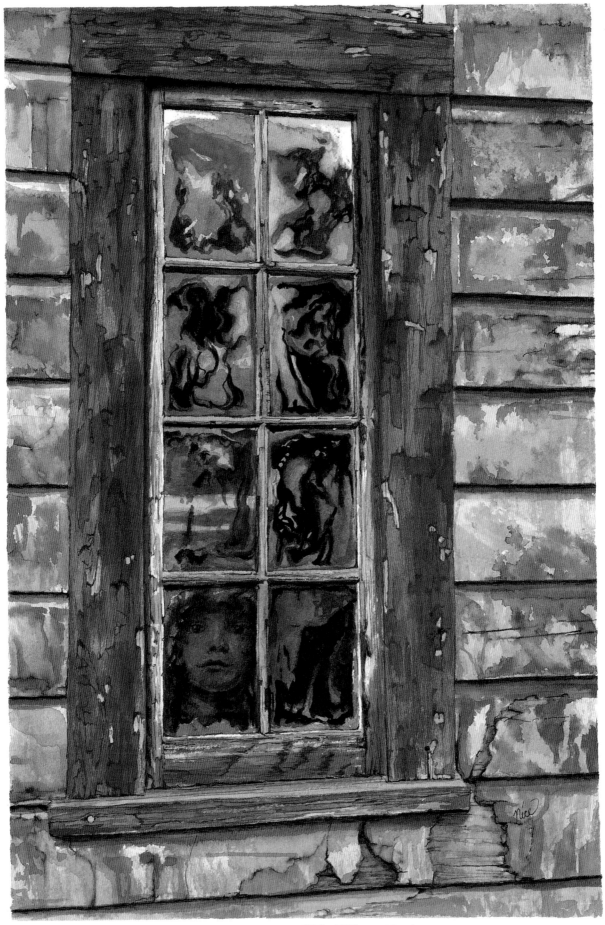

RED WINDOW, 10¾" × 7" (27cm × 18cm)
Wet-on-wet and layered watercolor washes accented with colored ink work.

WINDOWS TO THE PAST

Windows have personalities, reflecting the soul of the dwelling to which they belong. There are so many shapes, so many styles, each a silent witness to history unfolding. Even the panes of glass can be unique. Some are smooth and clear, creating mirrorlike reflections. Some bear cracks in spiderlike patterns, or have chunks missing, offering the viewer a mixed picture of outer reflection and unhindered sight within. Still others gain personality from bits of old house paint clinging to their edges and moss sprouting from the moulding. My favorites are the really old windowpanes, full of bubbles and ripples. Their reflections are twisted and garbled into fantastic patterns that bear little resemblance to the original image. Even objects seen through the glass are distorted into shapes that would make Picasso proud. Rippled glass leaves the viewer free to ponder design and color. Consider the image on the opposite page. The reflections in the wavered glass have been misshapen into uninhibited designs of Cobalt Blue, Ultramarine Blue and Payne's Gray. The shapes are whatever you want them to be. And what of the mysterious face? Is it a reflection, a curious watcher from within or a phantom from the past? You decide.

In this chapter we'll peek into some intriguing windows. I'll show you how to depict a variety of glazed panes and how to create window moods with interesting frames, building materials, greenery and bits of local color.

Depicting Clear Glass

When the window panes are clear, clean and smooth, and the light is not reflecting off the surface, the panes of glass are nearly invisible. The artist can therefore concentrate his efforts on the shapes, shadows and designs behind the glass, and just hint as to the existence of the pane itself.

When working in pen and ink, a few diagonal streaks will help suggest the surface of the glass. Keep them narrow and roughly at the same angle. A few pencil guidelines will help.

(.18, 1 & 2)

A combination of diagonal lines and solidly inked areas works well to suggest clear window panes seen at a distance.

Crosshatched window frame.

A wash of watercolor adds vibrance to this sketch of an antique store window.

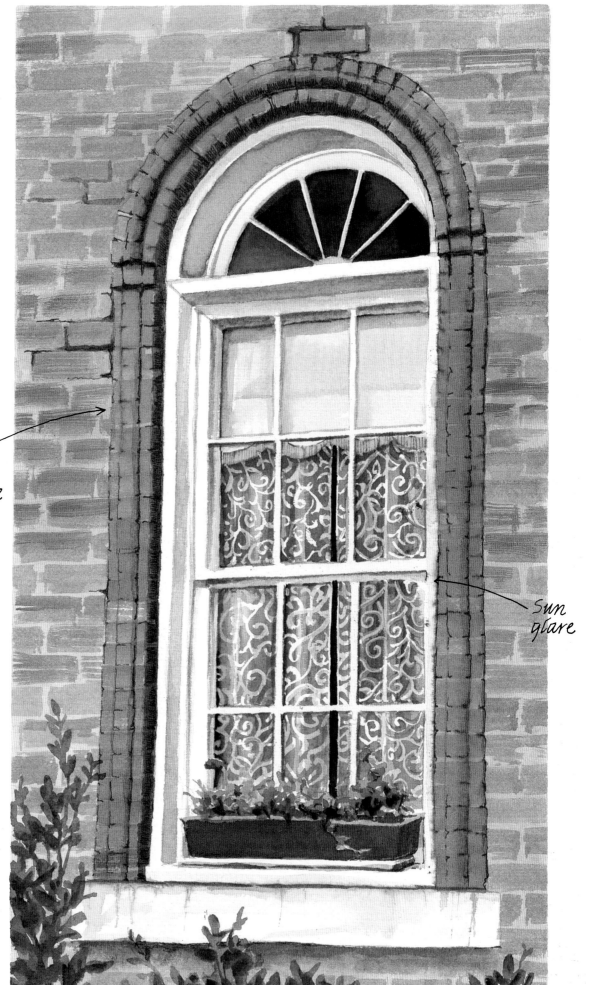

This courthouse window was painted as if the glass were nonexistent. Only a touch of sun glare reveals its presence.

Sun glare

The lacy curtain design was masked out with liquid frisket.

Window Reflections

When light rays fall on an object, part of the light is absorbed and the rest bounces back off the surface, carrying the image (shape and color) of the object it just struck.

If that light in turn strikes a very smooth surface, such as a window pane, at an angle, it will bounce back at the same angle, heading in the opposite direction.

If a person happens to be facing towards these reflected rays, he will see a mirror image, which will appear muted in color and reversed from left to right.

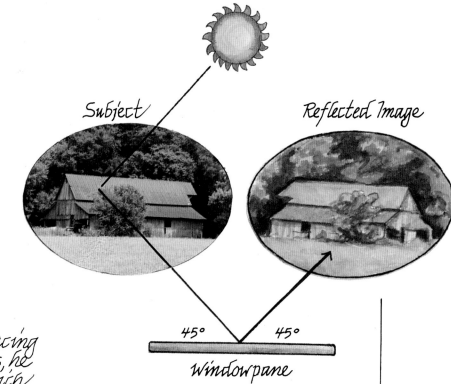

Subject

Reflected Image

45° 45°

Windowpane

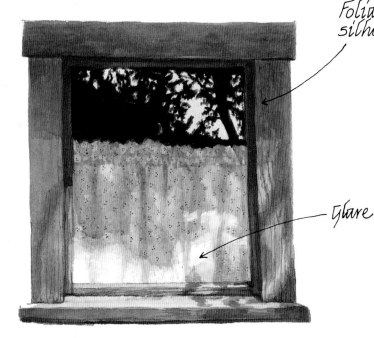

Foliage silhouettes

Glare

Direct sunlight reflecting off a window causes a spot of glare - a dazzling bright reflection that can be depicted by leaving the paper white.

If the sunlight is filtered through tree branches, shadowy foliage silhouettes are seen.

Barn scene reflected in window panes.

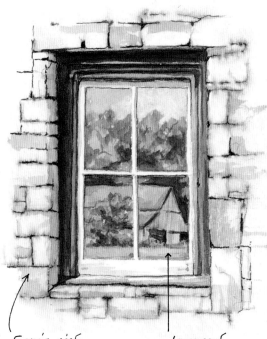

Sepia ink work over a damp wash.

Layered watercolor washes.

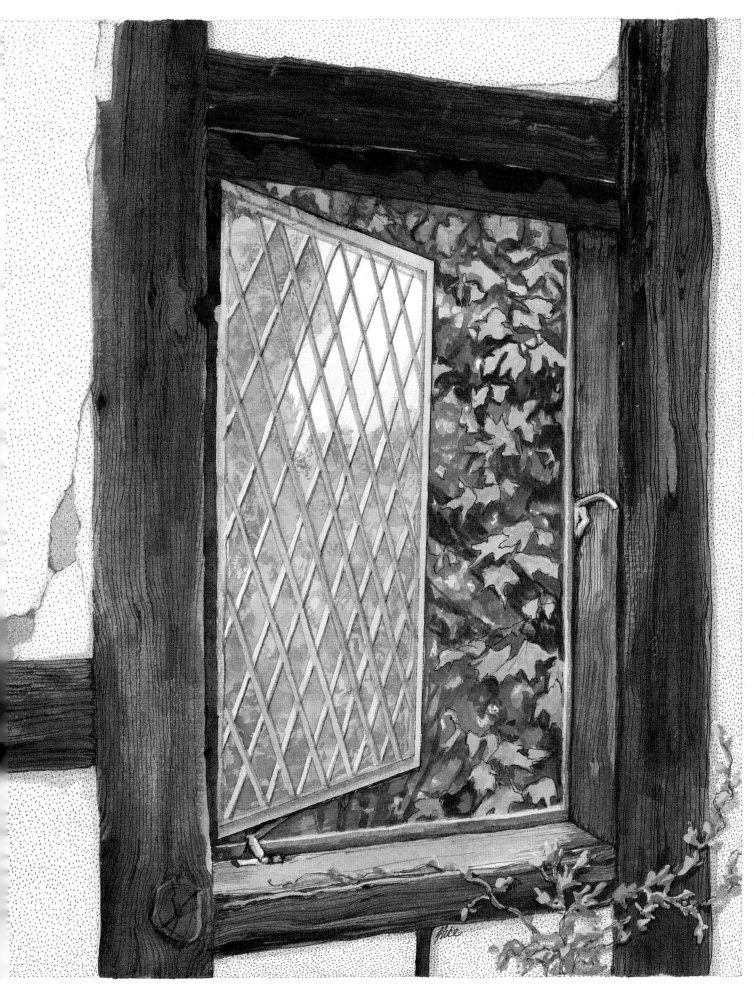

COTTAGE WINDOW REFLECTION, 10″×8″ (25cm×20cm)
Watercolor textured with colored ink stippling and wavy lines.

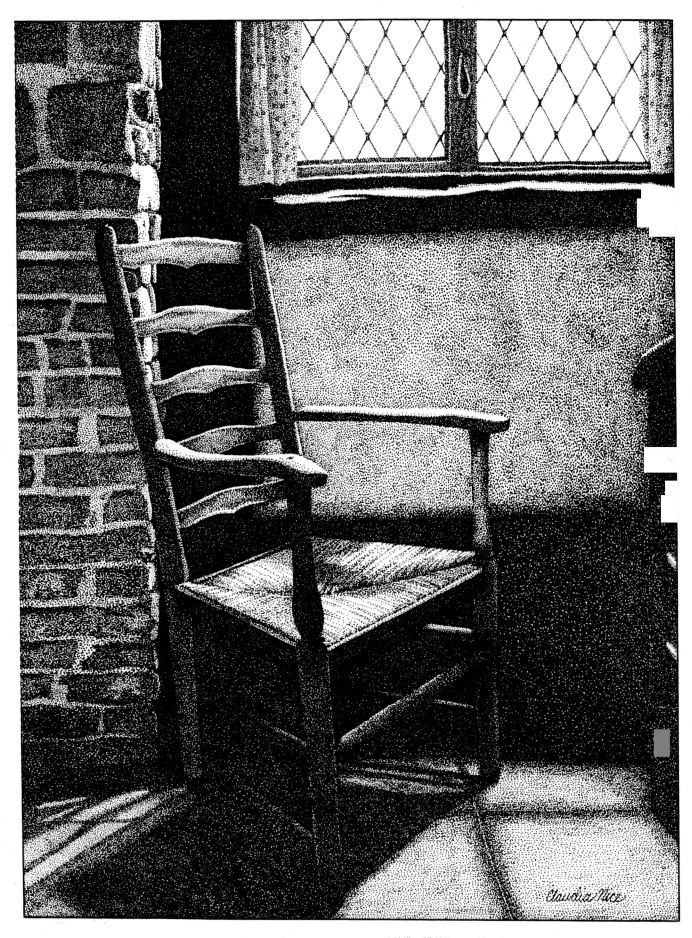

CHAIR BY THE COTTAGE WINDOW, 10½″ × 8″ (27cm × 20cm)
This piece was stippled using Rapidograph pen sizes (0.18), (0.25) and (0.35). The window
panes are uninked to suggest the strong sunlight entering the room.

Stained Glass

Stained glass windows, illuminated from behind, are vivid in color, light play and texture. The dark edging surrounding the glowing glass is rich in contrast.

I used a no. 7 Rapidograph pen and India ink to represent the lead edging. The ink work can be done either before or after the glass is painted. ——→

Vibrant washes applied in layers gave the glass its glowing appearance. Wet-on-wet techniques were used on the rose petals.

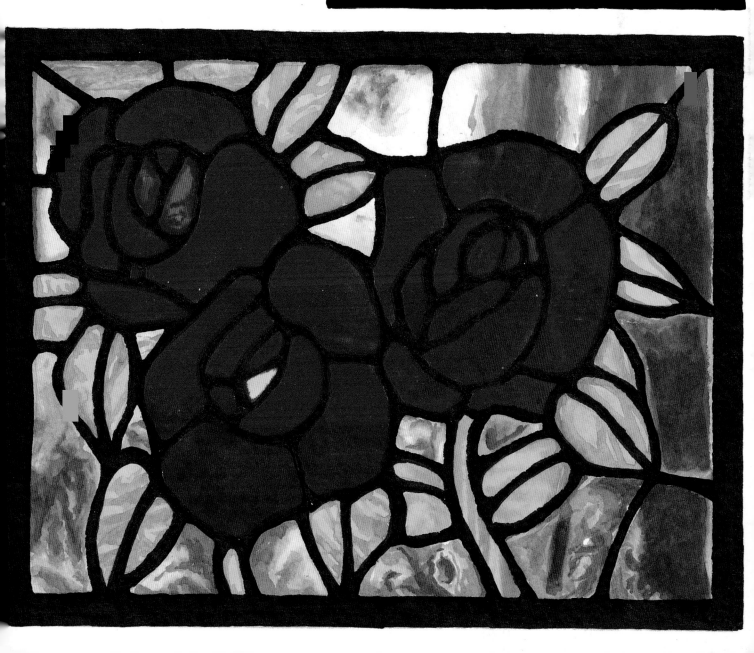

Wavy Glass

Imperfect in its smoothness, old-time wavy glass produces distorted reflections. Images become undulating ribbons of disconnected color and surrealistic shapes.

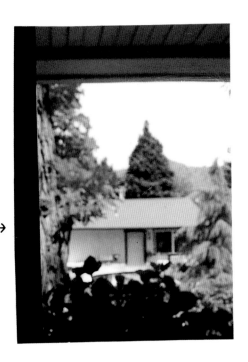

Actual image seen through non wavy glass window.

To make it into a wavy glass reflection, it must be both reversed and distorted.

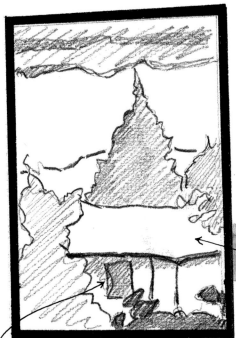

Note: In the reversed image the dark window is now on the left side of the door and placement of the foreground trees is switched.

① Start with a pencil study to determine shapes and values in the reflected image.

② Sketch the finished design lightly in pencil and lay down the preliminary water-color washes. (Work from the lightest values to the darkest.)

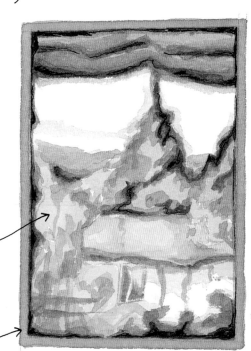

③ Deepen the values and define the distorted shapes by layering on additional washes. Do not over blend one layer into the next. Edges in wavy glass reflections tend to be distinct.

④ Subtle use of pen and ink work will help define the window frame, darken heavy shadow areas and add impact to the reflection.

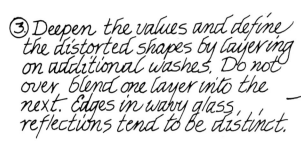

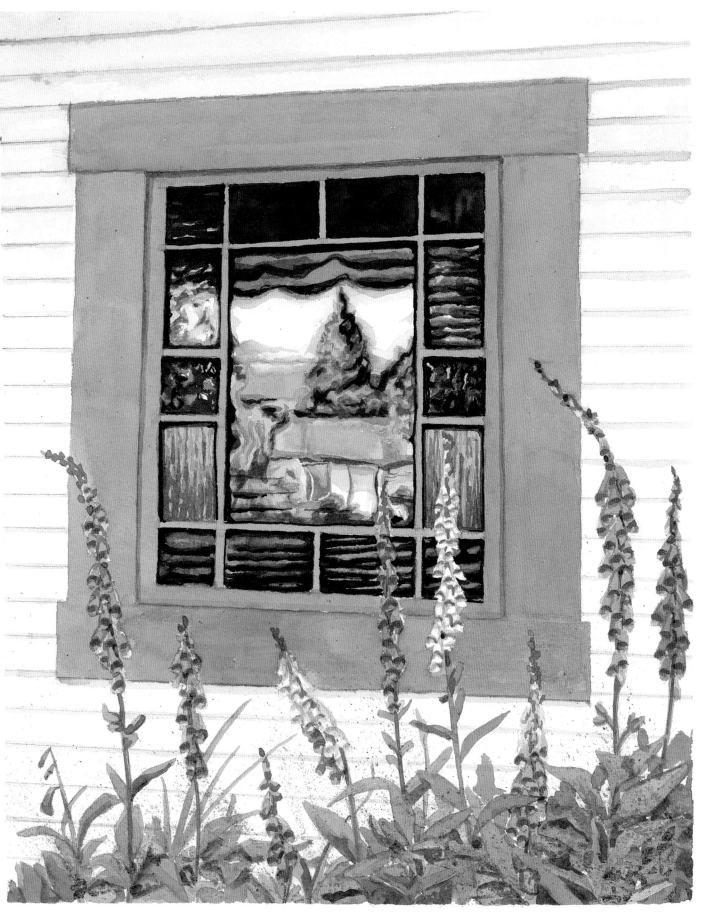

WAVY GLASS AND FOXGLOVES, 9½″ × 7½″ (24cm × 19cm)
In this painting the center pane of wavy glass is complemented with side panels of deeply rippled colored glass.
Since the stained glass is not lit from behind, the viewer is only given a hint of its true color.

Old, Dirty Windows

As dust, dirt and fly specks gather on a window, it loses its transparency. Covered with a patina of grime, glass appears streaked, dull and gray in color. There are few reflections. Here's how to get that grimy window look!

① Lay down a blue-gray wash of ---- Payne's Gray

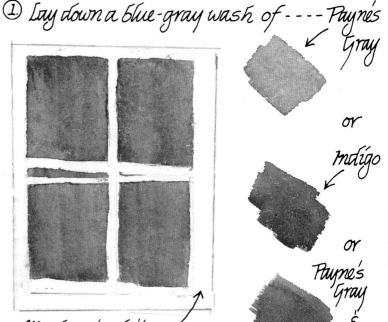

or

Indigo

or

Payne's Gray & Burnt Umber
(for more warmth)

Mask out white frame areas.

Payne's Gray / Burnt Umber mixture.

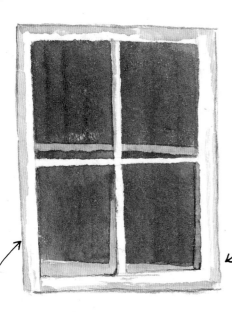

② Remove masking and paint the window frame.

Spattering adds grit.

Water spots add a cobweb look!

③ Re-dampen each pane of Glass. Depict streaks by working selected patches with a no. 4 round brush and lifting paint with a paper towel. Water spots and spatter also add good texture to dirty windows.

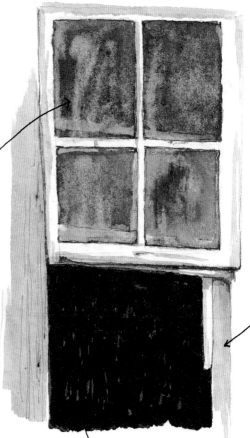

Add some warm earthy washes to the lower frame.

Open window area was first painted with Payne's Gray, then inked with a no. 7 pen.

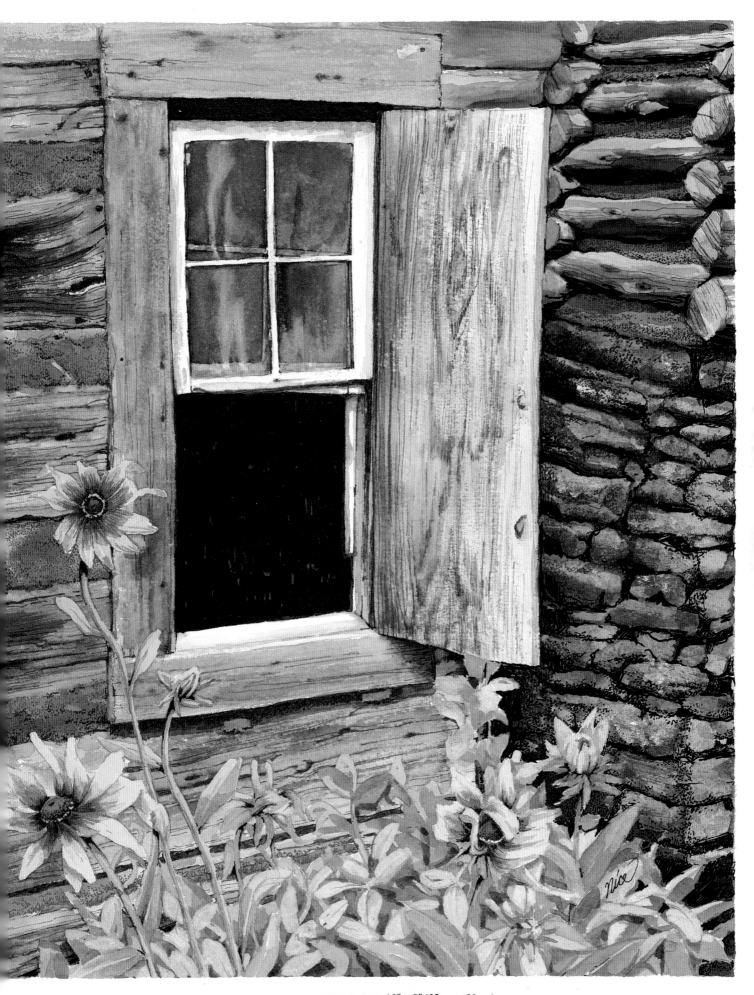

CORNER CABIN WINDOW, 10″ × 8″ (25cm × 20cm)

The cabin, window frame and stonework were textured with stippling and wavy lines. Drybrushing was used to further accent the wood.

Broken Windows

Partially broken-out panes set against dark interiors make a nice contrast. Such windows are often long abandoned, and go beyond dirty to downright gritty.

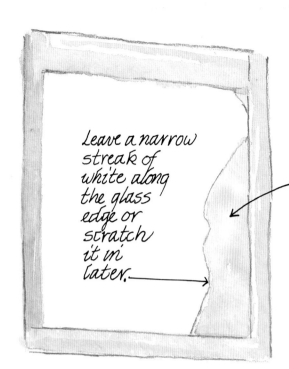

Leave a narrow streak of white along the glass edge or scratch it in later.

① Begin with light earthy washes of neutral gray and Yellow Ochre, applied wet-on-wet. Use the same washes to drybrush in the window frame. Let dry.

② Layer on a second wash of pale Payne's Gray or Indigo, allowing plenty of the first layer to show through. Spatter the window pane to add a gritty effect.

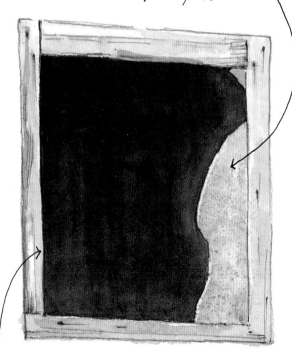

Darken the interior with heavy washes of Indigo / Sepia.

③ Texture the wooden frame with drybrushing and Sepia ink work.

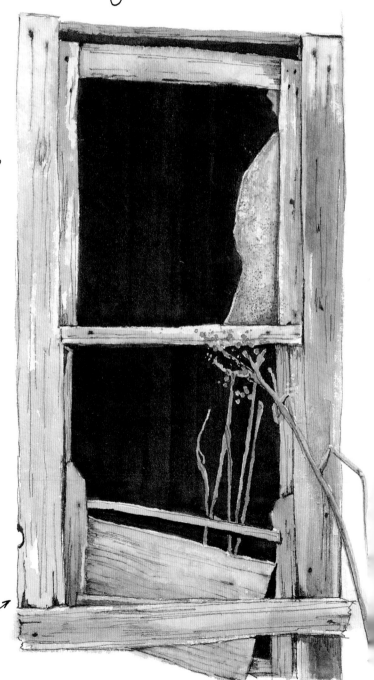

Cracked window panes can be suggested by painting each broken section separately, then subtly defining the cracked edges with a few fine ink lines and razor-scratched highlights.

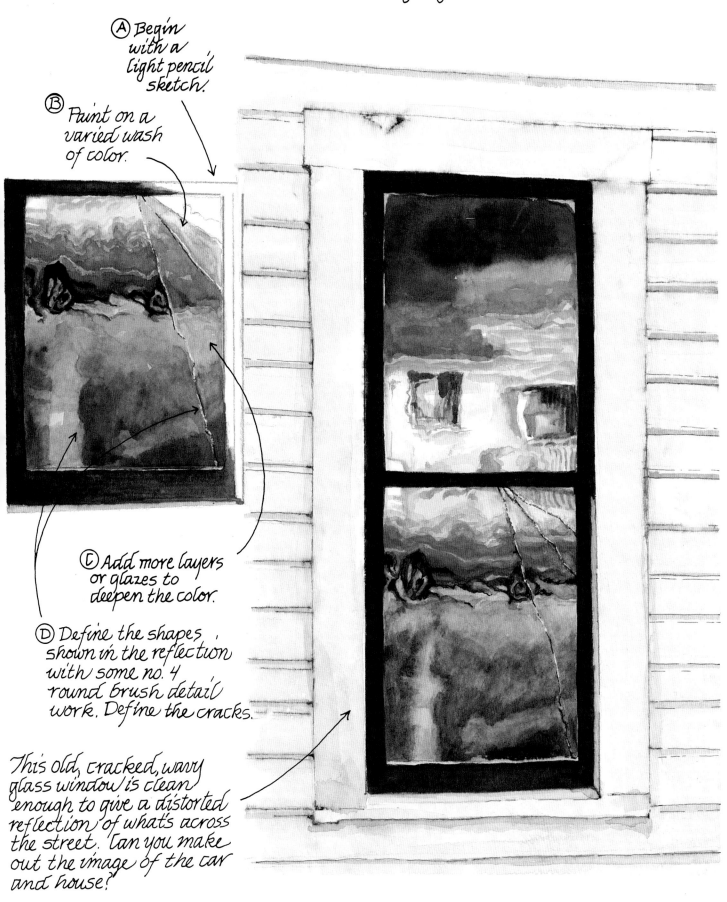

Ⓐ Begin with a light pencil sketch.

Ⓑ Paint on a varied wash of color.

Ⓒ Add more layers or glazes to deepen the color.

Ⓓ Define the shapes shown in the reflection with some no. 4 round brush detail work. Define the cracks.

This old, cracked, wavy glass window is clean enough to give a distorted reflection of what's across the street. Can you make out the image of the car and house?

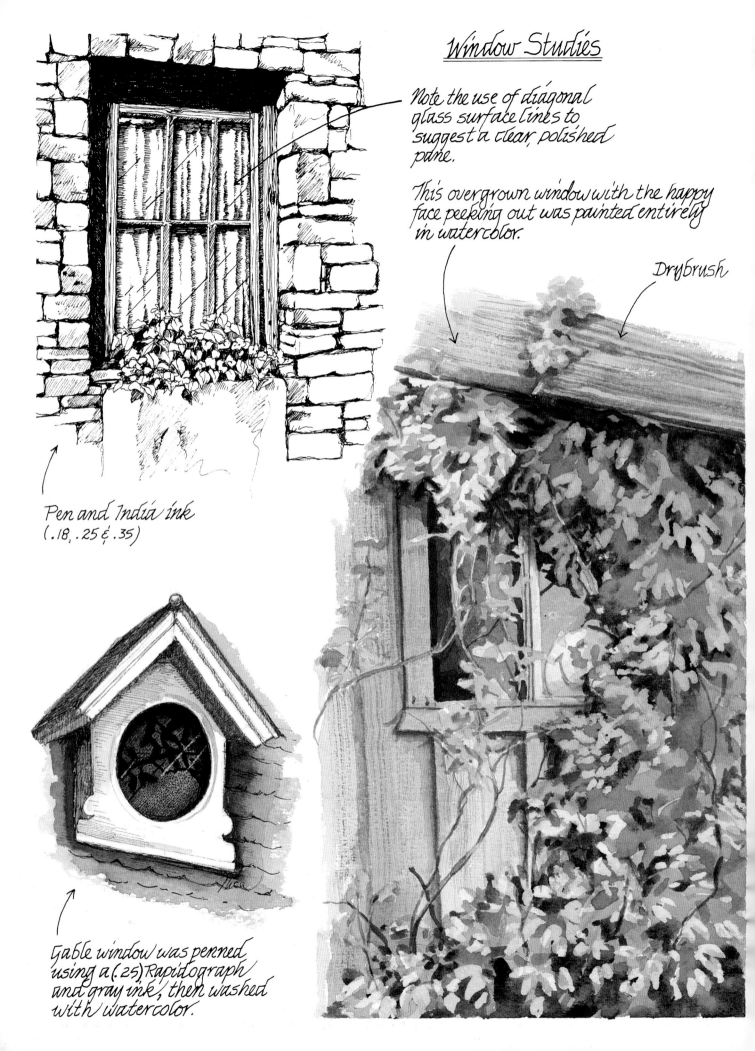

Window Studies

Note the use of diagonal glass surface lines to suggest a clear, polished pane.

This overgrown window with the happy face peeking out was painted entirely in watercolor.

Drybrush

Pen and India ink
(.18, .25 & .35)

Gable window was penned using a (.25) Rapidograph and gray ink, then washed with watercolor.

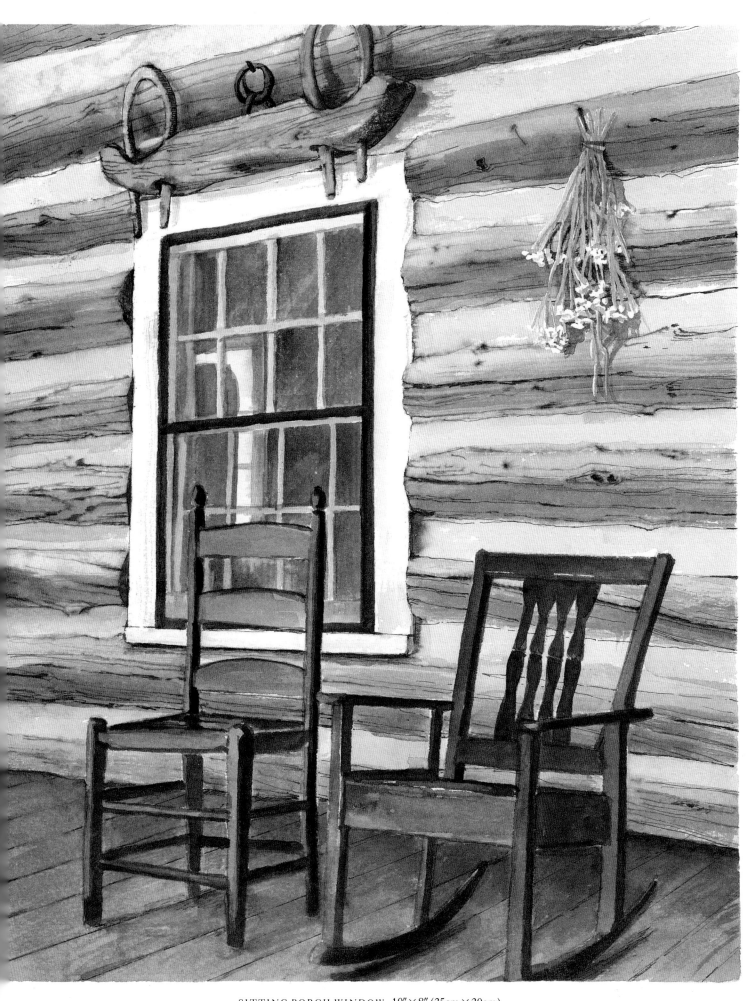

SITTING PORCH WINDOW, 10″×8″ (25cm×20cm)
Layered watercolor washes and damp-surface Sepia pen work were used on this painting. Note the light coming from an inside window.

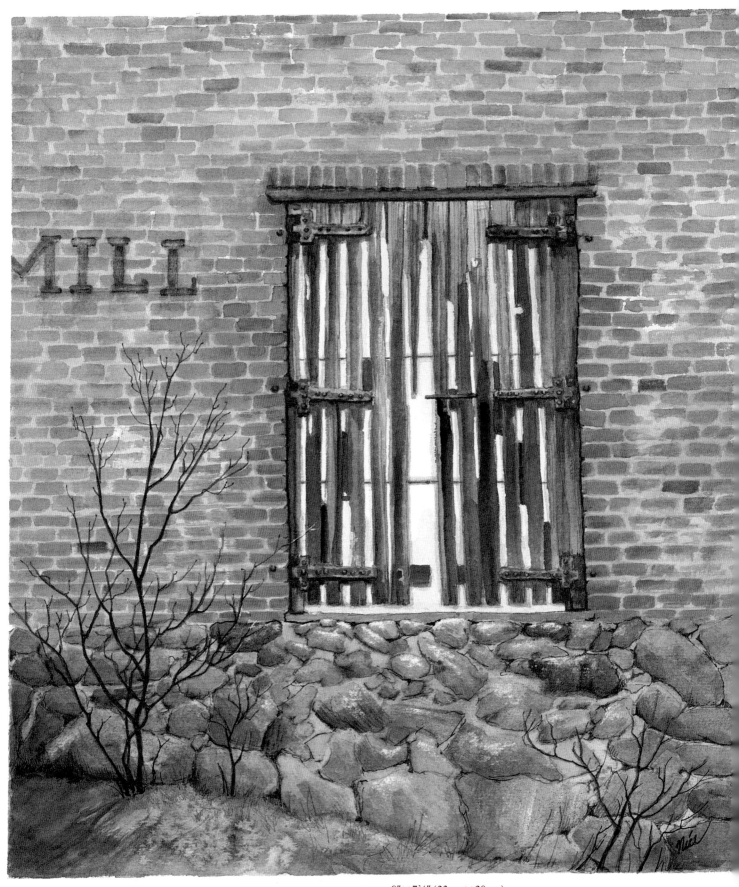

BACKLIT MASONRY WALL, 9″×7¾″ (23cm×20cm)
Layered watercolor washes, detailed with Black, Sepia and Burnt Sienna inks.

BRICK, ADOBE AND STONE

In the beginning of history, man pried stones from the earth and piled them up to form altars to his gods. As he became better at it, foundations, walls and even the Great Pyramids of Egypt were built. Brick is the oldest man-made building material. The early descendants of Noah took clay from the plains of Shinar, formed it into bricks and fired it. "And they had brick for stone and slime they had for mortar" (Gen. 11:3). And they commenced to build the Tower of Babel.

Other early inhabitants sun dried their bricks and made dwellings of adobe. Not only were all these earthy building materials favorites with the ancient masons, they have endured through time and are still used today. Brick in various shapes and refinements still forms the walls of hovels, houses and various buildings of state. Stone still shapes the foundations for cowsheds and cottages; stuctures the walls of lodgments, castles and colleges; and adds majesty to the columns of cathedrals and the towers of temples. Their strength and earthy nature is what gives these materials their appeal, to both architect and artist. The natural pigments of carbon, copper, iron, sienna, umber and ochre wash their surfaces with color. A myriad of rich texture ranging from smooth to rough, gritty, grainy and crumbly adds to their character.

If you wish to sketch them, you must get to know them. Walk the city streets and look up. You'll find them there in all their variety. Travel down a rural road. They are there, too, perhaps a bit more rustic. Touch them, study them and when your mind fills with earth tones, textures and techniques, you are ready to paint them. This chapter will help you on your way.

Depicting Brick

The colors of brick are the warm hues ranging from yellow-orange through red-violet, muted in varying degrees with their complementary colors.

The texture of brick is coarse and somewhat abrasive. Add lichen, moss, mortar splats and dirt, and the textures and the texturing techniques that can be used to suggest them are endless. Of course the closer you move in on the subject, the more vivid the colors become and the more graphic the rough surface being depicted.

A few premixed tube colors that work great for basic brick hues.

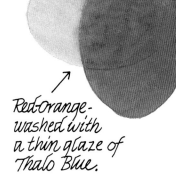

Orange-washed with a thin glaze of Ultramarine Blue.

Red-Orange-washed with a thin glaze of Thalo Blue.

| BURNT SIENNA | LIGHT RED | BROWN MADDER | INDIAN RED | VENETIAN RED | PERYLENE MAROON |

Liquid frisket spatter

Detailed Brick

① Mask mortar areas with liquid frisket, then paint with a varied wash of brick hues.

② While still very moist, sprinkle the brick with paint spatter and dry sand. Let dry and remove sand.

③ Wash each brick with a thin glaze of its complementary color. In this case I used Thalo Blue. Let the glaze dry and remove the frisket.

Gray ink stipple work. (.25)

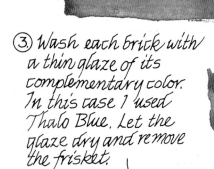

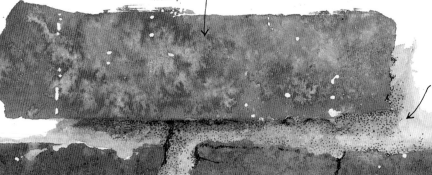

④ Tint the mortar with thin washes of color. Dirty palette grays and browns work well for this.

⑤ Texture both the brick and mortar with gray, sepia or black ink work. Moistening an area will cause strokes to fray and soften.

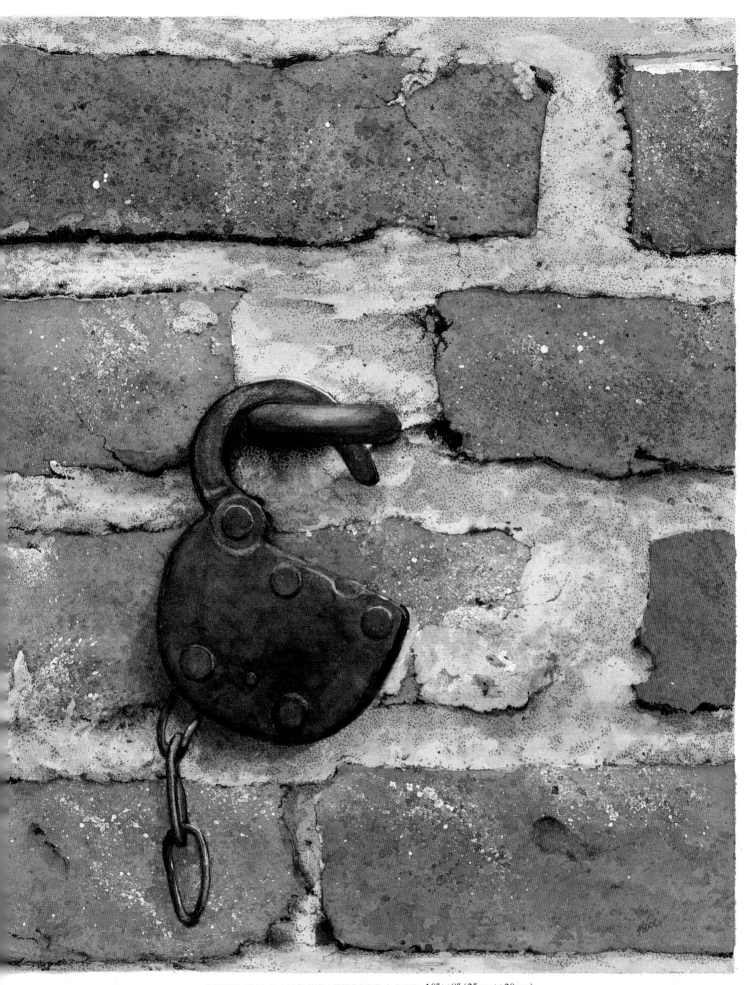

BRICK WALL AND WEATHERED LOCK, 10″×8″ (25cm×20cm)
Layered watercolor washes and colored ink work. The patina on the weathered lock was achieved with layered
glazes (orange, blue, indigo), and the highlights were lifted out with a damp brush.

Brick At A Distance

When viewed as part of a distant structure, the pattern the brick forms and its color are the most important factors. Age, distance and bright sunlight all tend to lessen the intensity of the color.

Pencil guide lines will help keep the bricks even.

① Begin with a warm, pale wash to seal the paper. Dirty palette colors work well.

Stagger the pattern.

② Use a 1/8 to 1/4-inch flat brush to paint in the brick colors. Vary the hue.

③ Glaze brick and mortar with a thin complementary wash, to mute the color. Add shadows with a gray or Sepia pen.

Harsh sunlight causes the brick to appear faded. (Use thin, pastel washes.)

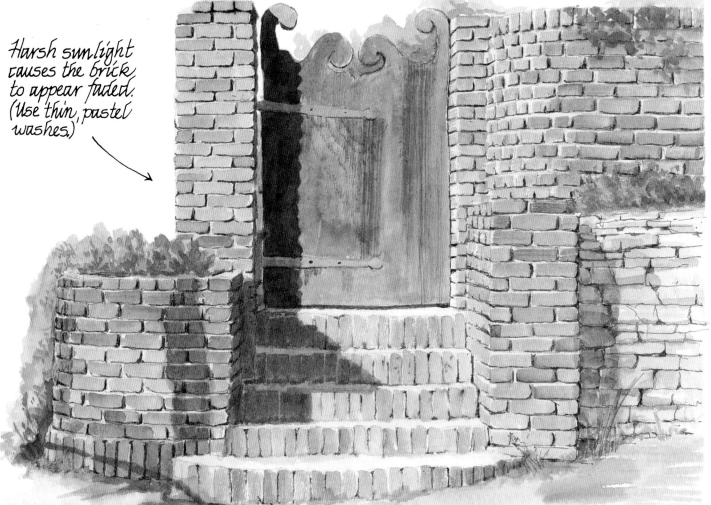

Buildings that are far enough away so as to be part of the background are painted in a simplistic manner.

Colors are muted using complementary mixtures, and faded using lots of water in the mix.

Value changes and shadows are used to define shapes rather than outlines and pen and ink detailing.

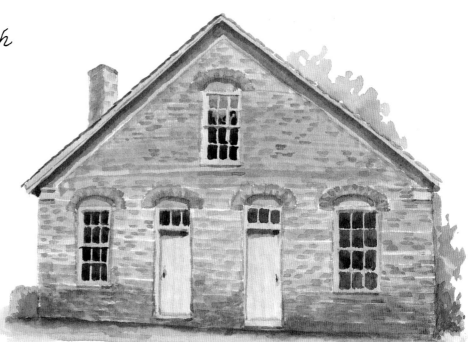

Block in the brick areas of the building with a muted, brick-colored wash. Use an 1/8-inch flat brush and stroke in the same direction the rows of brick would run. Let dry, and darken shadow areas.

Suggest a bit of brick texture by using a small round brush and a slightly darker paint mix to lay in a few random brick shapes.

Note: Small, lost white areas, like window frames, can be reclaimed with the scratch of a sharp razor edge.

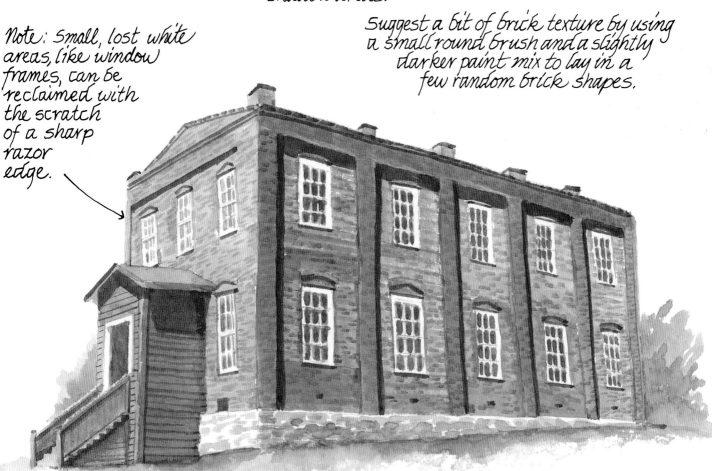

Historic brick schoolhouse
Columbia, California

107

Pen & Ink Bricks

Bricks seen at a distance can be suggested quite well using tiny rows of parallel ink lines - (.18 or .25). A few pencil guide lines will help keep the rows straight. The rows may be smaller at one end, following the perspective of the building.

Light mortar ~ leave open spaces between the bricks.

Dark mortar ~ outline bricks with a (.30) size pen.

Pen work tinted with watercolor wash

Nice

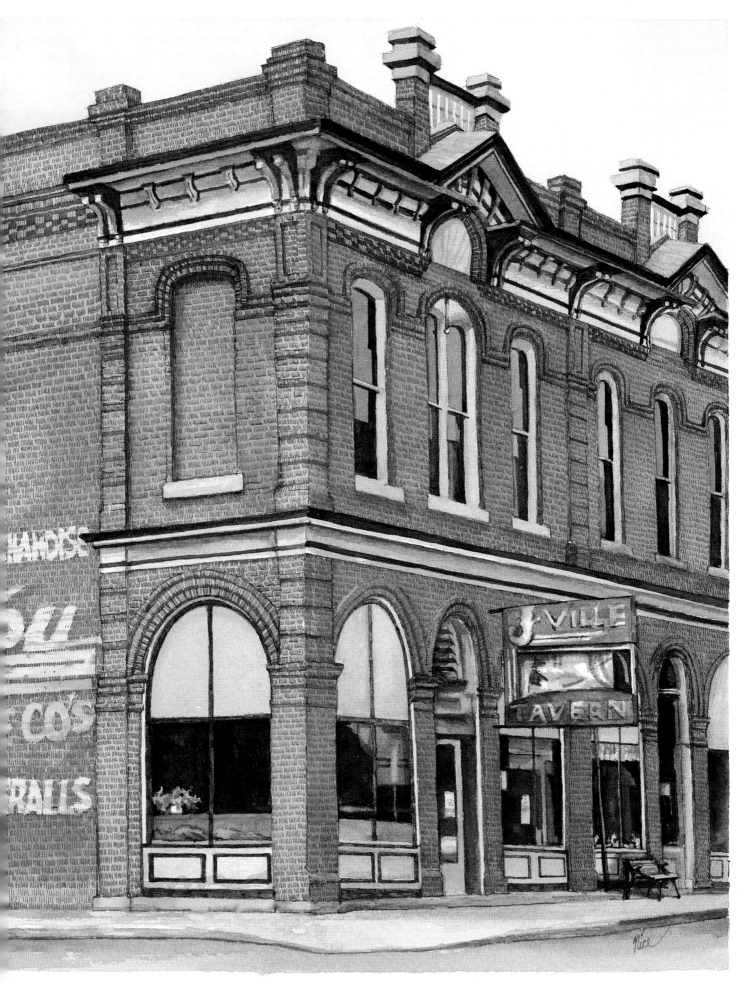

MAIN STREET, JACKSONVILLE, 10″ × 8″ (25cm × 20cm)
A detailed study in brown pen and ink, tinted with watercolor.

Adobe

Adobe bricks are usually made from clay or yellow river silt. They are sun dried rather than baked, giving them a rough, crumbly texture as they begin to weather.

Shown on this page are some gritty, crumbly texturing techniques that work great for depicting adobe.

A varied wash of Yellow Ochre, Burnt Umber and Sepia impressed with river sand and left to dry. The sand was then brushed away.

Layered sponging

Spatter, layered over a damp Yellow Ochre / Burnt Umber wash.

This varied wash was textured with water spatter and Sepia pen work while still moist. Drybrushing was then used to add final touches.

Sienna, and Sepia colored inks stippled over a dry, varied wash.

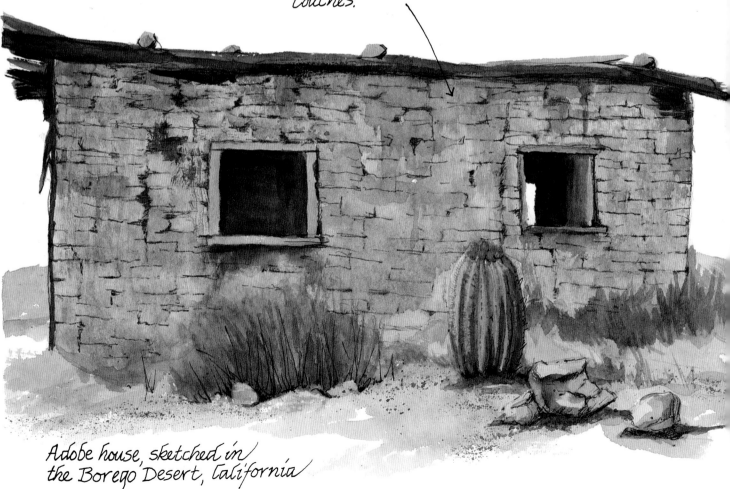

Adobe house, sketched in the Borego Desert, California

Stucco

Stucco is an exterior finish applied over bricks or wooden frame walls. It's usually made out of cement, sand and lime, mixed with water, and applied wet. The finish may be granular and rough, or fairly smooth.

Rough-surface stucco can be depicted using the "adobe techniques" shown on the opposite page. For a smooth stucco look, try flat, blended washes and contour line ink work.

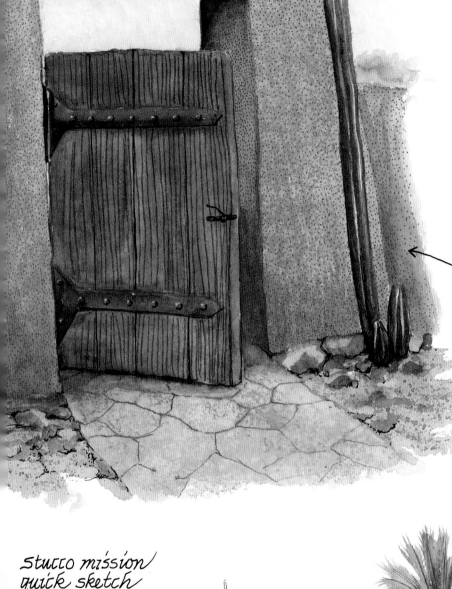

Varied washes, textured with a painted sponge, stamped over the surface (colors: Venetian Red, Brown Madder and Sap Green, mixed). Or combine warm red and blue-green to create your own reddish pink earth tones.

Finish with stippled pen work ~ Burnt Sienna ink. (.25)

Stucco mission quick sketch rendered in Sepia ink, (.25) Rapidograph and water-color wash.

This stately manor, with its smoothly plastered walls, was painted using layered watercolor washes.

Crosshatch works well to depict the rough surface of a primitive stucco-covered log cabin.

WEATHERED STUCCO, 10″ × 7¾″ (25cm × 20cm)
The stucco covering on this old brick and frame house has deteriorated badly, providing a wonderfully
textured subject. Layered washes and damp-surface pen work were used to portray it.

Stone Masonry

The techniques for depicting stonework are as varied as the rock used to construct them. Shape, shadows and texture are the most important factors. Colors are muted and earthy.

Shown on this page are some of the simpler methods that can be used to suggest chiseled stonework.

A simple preliminary pencil sketch of a stone arch.

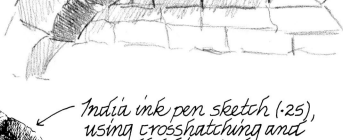

India ink pen sketch (.25), using crosshatching and parallel line strokes.

A watercolor wash, using dirty palette grays and damp-surface, sepia pen detailing.

Here, brown ink work was stippled over a dry watercolor wash.

The drawing of the Alamo (oposite page) was rendered using (.18)&(.25) Rapidograph pens.

Stippling was used to show the gritty roughness of the stone masonry and the delicate mesquite leaves.

The bold solid areas provide contrast and impact.

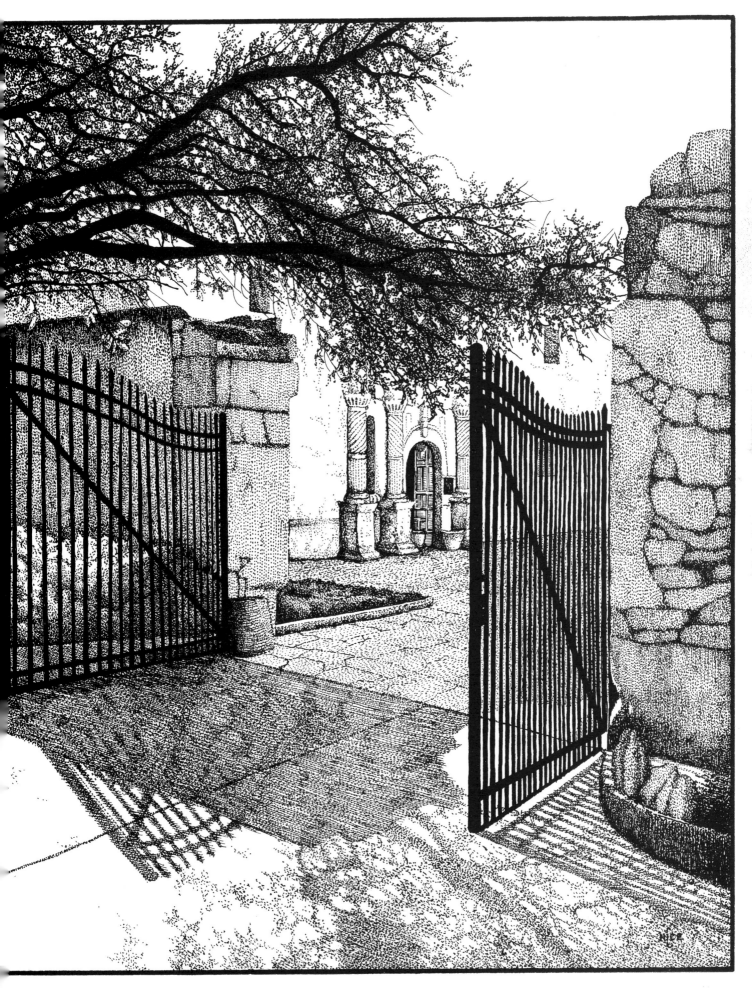

THE ALAMO, 10″×8″ (25cm×20cm), Stippled pen work.

When stonework is viewed close enough to see its textured surface, watercolor special effects can be a fun and efficient way of aptly portraying it.

Pen work, over a damp surface, was used to further define and detail each of the examples shown here.

Textured with plastic wrap, pressed into a wet, varied gray wash, then gathered into horizontal ridges and left to dry. This effect takes both luck and skill!

Scribbly India ink pen lines suggest cracks and shadows.

Drybrush work, streaked over a Burnt Umber wash. A 1/4-inch flat brush was used, stroked in a horizontal direction.

Mortar areas were masked out with frisket.

Payne's Gray wash, scraped with an aquarelle brush end while still moist.

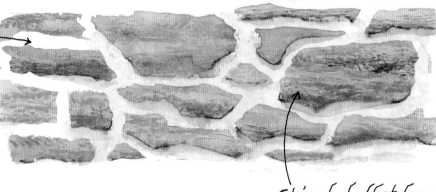

Stippled flat brush texturing over a dry watercolor wash.

Base "mortar wash" of Burnt Sienna, stippled with Burnt Sienna ink. (.25)

116

The stones in the red barn painting below were textured using a blotting technique. The mortar was painted first and left to dry. Then each stone was painted with an earthy brown (A), and blotted with a crumpled facial tissue (B). I varied each stone color slightly.

A. B.

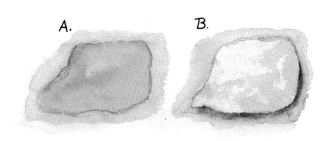

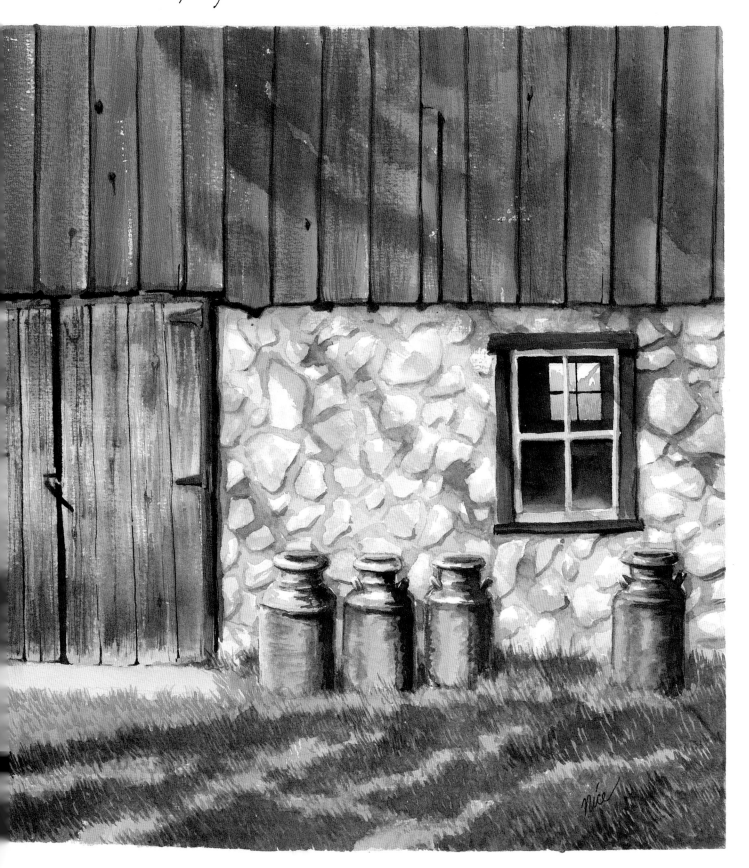

To depict a specific type of rock, consider the surface characteristics of that particular stone. Then choose a texturing technique that best suggests that quality, at the distance you are viewing it. Don't overdo it!

It's effective to contrast the stones against mortar or materials with different textures.

Basalt ~ Rough, with abrupt, broken edges.

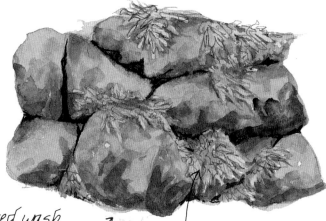

Layered wash, blotted with a crumpled tissue.

Contrasted against soft scribble-line moss.

Scribble lines

Layered, sponging

Stippled mortar

Lava Stone ~ Craggy, peppered with pits and depressions.

Contour ink lines.

Layered washes blended with a damp brush.

River Rock ~ Smooth, rounded contours.

Mortar is a flat wash, textured with parallel or contour ink lines.

Mortar was masked out, and rocks were painted, then textured with fine, dry surface spatter.

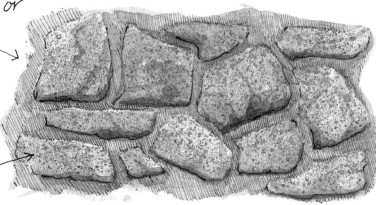

Spatter also works well to depict granite.

Field stone ~ Surface cracked and irregular, sometimes dusty or gritty.

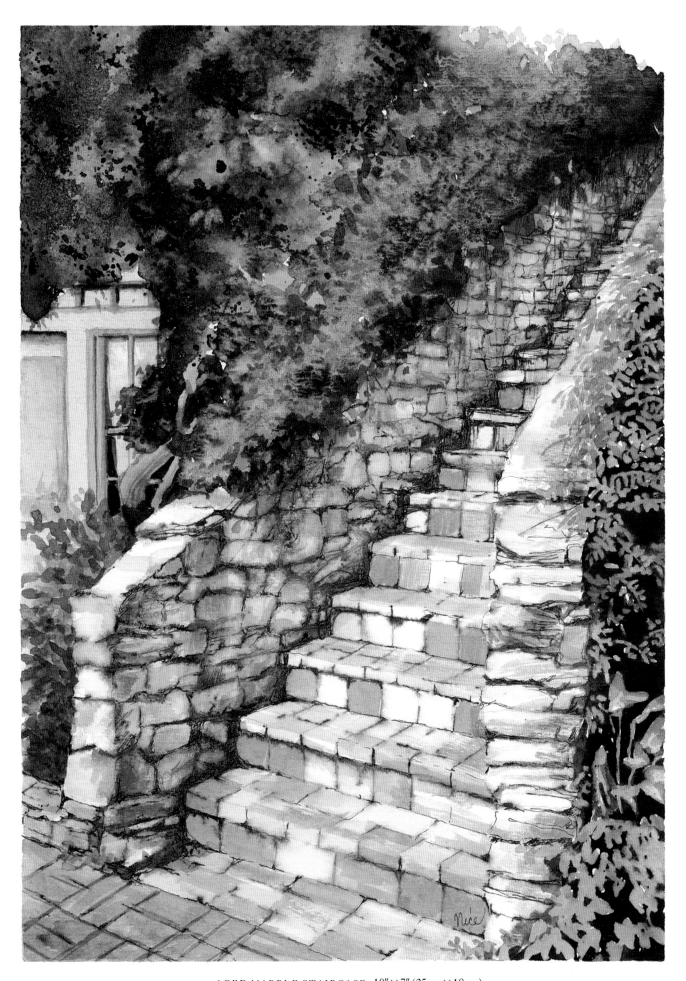

AGED MARBLE STAIRCASE, 10″×7″ (25cm×18cm)
This painting is layered with watercolor washes, then overlayered with damp-surface Sepia pen work (0.25).
The frayed, scribbly ink strokes add to the aged, weathered look.

Distant Stone Masonry

Often stonework is viewed as part of a larger structure, set far enough back that most of the building can be viewed.

When seen in the distance, the pattern of the stone masonry along with color and value contrast are the important qualities to be considered.

Here are a few examples. (There are lots of variation possibilities. Experiment!)

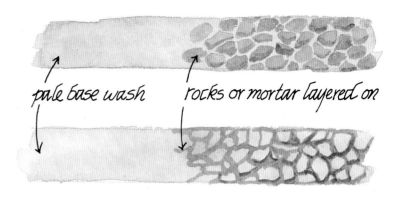

pale base wash

rocks or mortar layered on

Pen and Ink (.18 or .25)

pencil layout ink outline or filling in with parallel lines

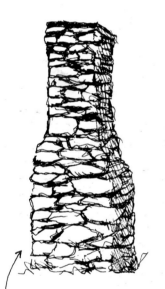

Sketchy look — loose, scribbly lines.

Misty look — parallel or contour lines with no outline. (.18)

Note the variance of color in the stonework.

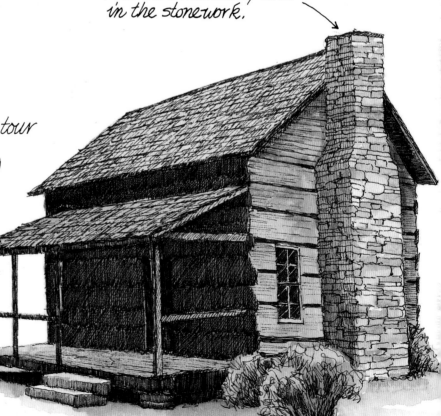

This pen sketch of an Appalachian cabin was drawn in India ink (.25) and tinted with washes of water-color.

The old Graphite
Mill, Bloomsbury,
New Jersey.
(.18, .25 and .50)

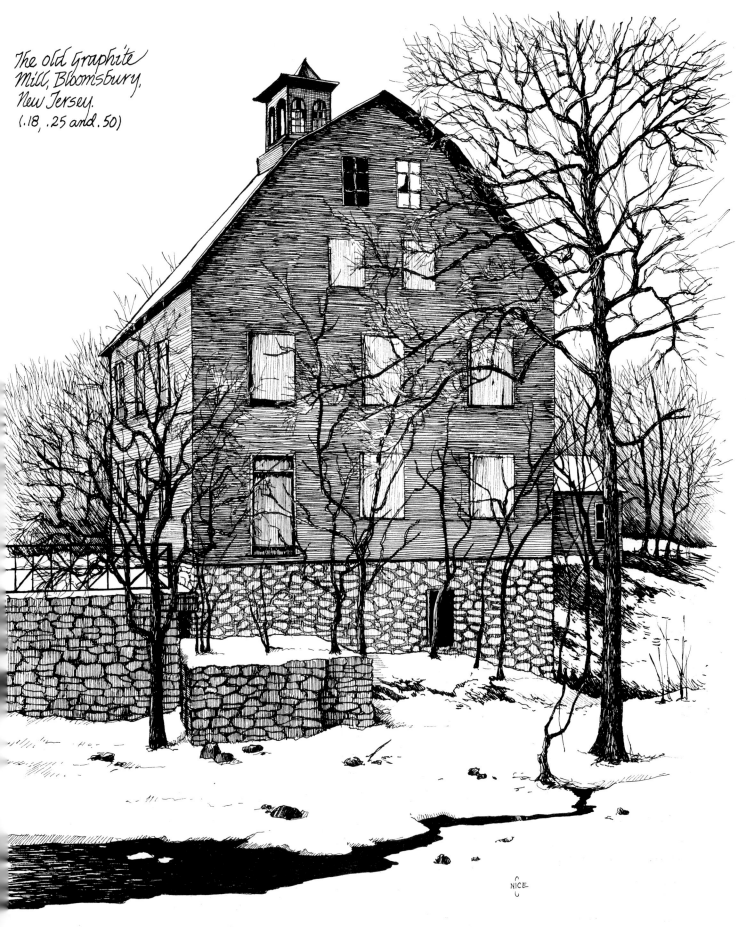

NICE

Winter is a good time to sketch buildings that would
normally be hidden behind leafy branches. Note the
two different types of stone work in the drawing.

WISCONSIN HOME, 4½″×7½″ (11cm×19cm)
Watercolor wash, drybrush and India ink.

CALIFORNIA STONE CABIN, 4½″×7½″ (11cm×19cm)
Pen and India ink with watercolor wash.

DERELICT CALIFORNIA MILL, 4½″ × 7½″ (11cm × 19cm)
Pen and Sepia ink with watercolor wash.

TENNESSEE SPRING HOUSE, 4½″ × 7½″ (11cm × 19cm)
Layered watercolor washes and gray pen work.

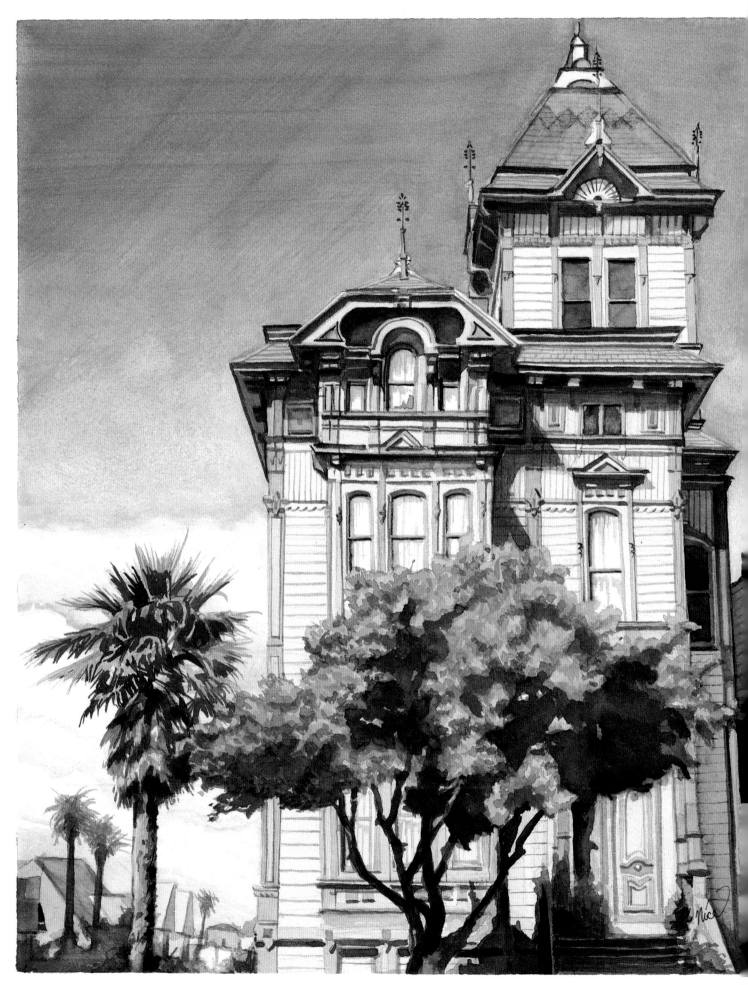

VICTORIAN TOWERS, 10″×8″ (25cm×20cm)
Layered watercolor washes.

PILLARS AND GINGERBREAD

Last we come to the grandes dames and painted ladies. I'm referring to the most magnificent of American dwellings—the antebellum mansions, with their stately columns, and the colorfully commanding Victorians, with their fussy ornamentation.

Like a refined and cultured matriarch, the Southern mansion stands in simple splendor. The lines are those of the understated beauty, borrowed from Grecian temples. The main focal points of these grand structures are the great porches and pillars, which speak of a leisurely, elegant lifestyle. In keeping with their dignified nature, the colors were subdued. White or the soft, rosy beige of brick were the preferred hues. The many symmetrical windows were trimmed with black or deep magnolia-leaf green. Although large and impressive, the antebellum mansion is not complicated. It is fairly easy to draw.

In direct contrast stands the Victorian. Built with the theory that more is better, these structures have it all. Towers, turrets, pillars, porches and a potpourri of fanciful trim make them as colorful and eye-catching as a queen in full regalia. Symmetry is often lost in the quest for fancy gingerbread embellishments. All the curves, cutouts, spindles and spires boggle the mind and present a challenge to the artist that's hard to resist. They are not easy to draw but can be conquered by drawing the basic structure first and adding the ornamentation systematically. Start in one location and spread outward, like putting the icing on a many-tiered cake, one layer at a time.

Whether you like the simple antebellum grandeur or the peacock splendor of the Victorian, you will find that these magnificent structures make great subjects. They are well worth seeking out!

Posts And Pillars

Supports used in the antebellum and Victorian mansions were usually quite ornate. Not only did they uphold porches and upper stories, but they served as focus points of the decor.

Victorian structures often had carved wooden posts, while Southern mansions boasted huge columns.

Corinthian style capital. Capitals and columns were carved from wood or stone, or formed from cement-type mixtures. Pen & ink. (.18)

Use ruled pencil lines to keep the the posts and pillars straight, then sketch the carved areas within the boundaries.

Carved Victorian porch post with "gingerbread." Watercolor washes.

Stone support pillar painted with layered washes.

Ionic style capital

Capital

shaft

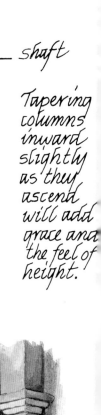

Tapering columns inward slightly as they ascend will add grace and the feel of height.

Base

Victorian carved wooden post. Watercolor washes and colored ink work.

In this miniature painting of the Hermitage, the tall, stately columns catch the eye and help offset the colorful brick work and thick foliage on the right.

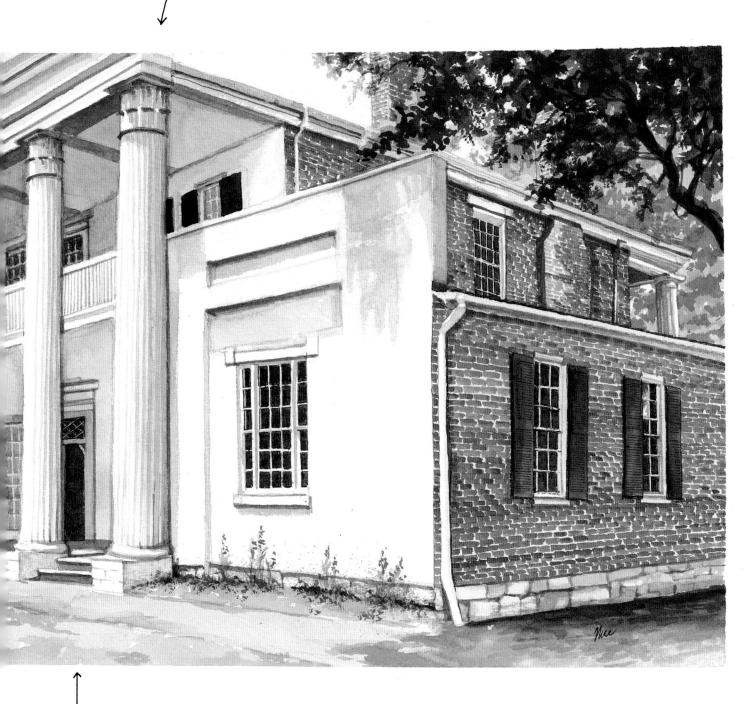

The color mixtures used to suggest the shadows on the columns and white portions of the building are varied combinations of Payne's Gray and Sepia. Burnt Umber was added to produce a warmer mix.

This painting is primarily layered washes, but gray ink was used to detail the shutters and darken the windowpanes.

An abundance of loose scribbly pen work and parallel lines gives these three old Southern mansion sketches a misty, dreamlike quality.

When a subject is just too symmetrical and perfectly balanced, try using trees, shrubbery, objects and even people to upset the balance just a little.

Houmas House
Burnside, Louisiana

Sketched in
Franklin, Tennessee

Belle Meade,
Nashville, Tennessee

The illustration on the opposite page would work equally well as a book cover, wall poster or greeting card. The mansion painted as part of the background is Oak Alley, located near New Orleans.

Although placing it across the center line in perfect balance breaks a basic rule of composition, in this case it was more important to illustrate the idea of formal elegance.

Note that the colors were kept soft and muted and the details are minimal, in keeping with a building seen at a distance.

The oak trees were easier to paint than they appear. The pale yellow-green spots were masked out, to be tinted in later. The greater portion of tree foliage is a varied wash of Hooker's Green, Sap Green and Payne's Gray, sprinkled with table salt and left alone to form a lacy, leafy texture.

The trunks are layered washes of Burnt Sienna, then Sepia / Payne's Gray. They were painted in last.

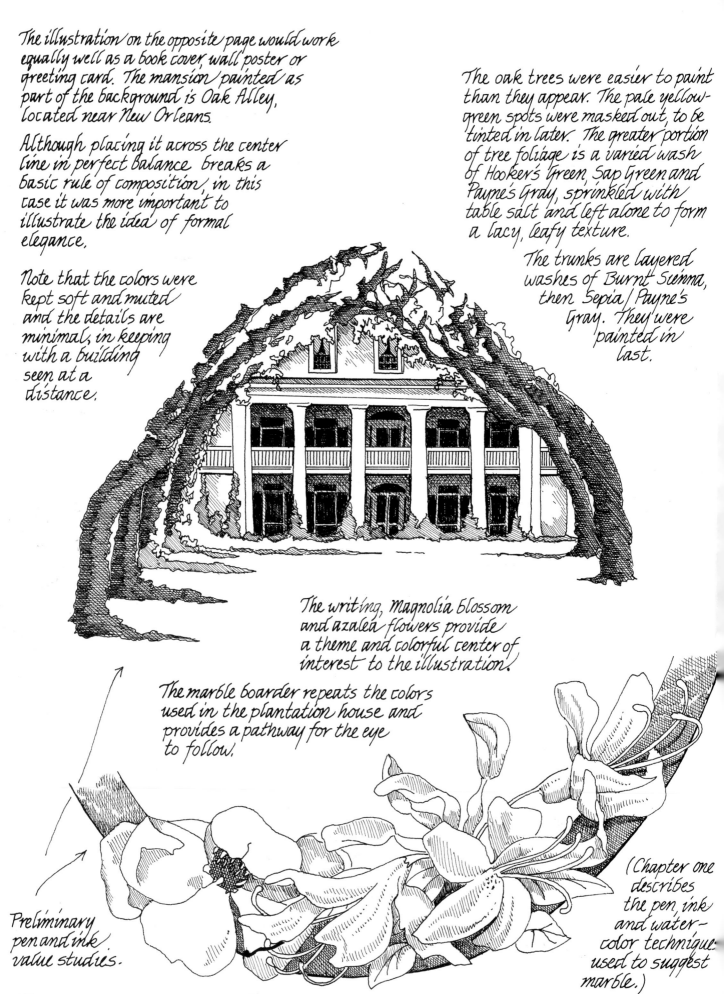

The writing, Magnolia blossom and azalea flowers provide a theme and colorful center of interest to the illustration.

The marble boarder repeats the colors used in the plantation house and provides a pathway for the eye to follow.

Preliminary pen and ink value studies.

(Chapter one describes the pen, ink and water-color technique used to suggest marble.)

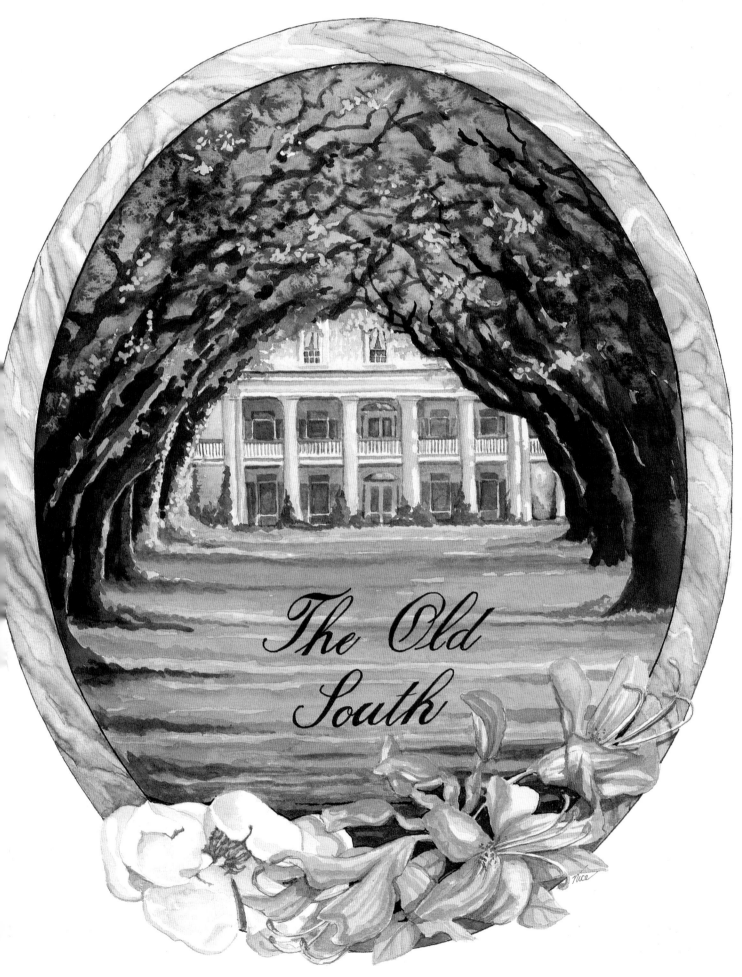

The Old
South

THE OLD SOUTH, oval on 10″ × 8″ (25cm × 20cm)
Layered watercolor washes and colored pen and ink work.

Towers And Steeples

One could hardly pass through a chapter on grand old buildings without mentioning the towers, steeples and cupolas that graced so many of them. They were especially popular on the churches, schools and public structures built in colonial America.

Here are a few of my Northern favorites, built in the 1600s and 1700s.

The belfry from the Old Dutch Church on the Hudson River.

Watercolor mixtures of Sepia and Payne's Gray

spire

From my sketchbook journal — Faneuil Hall, Boston (penned on an early spring morning - 1984)

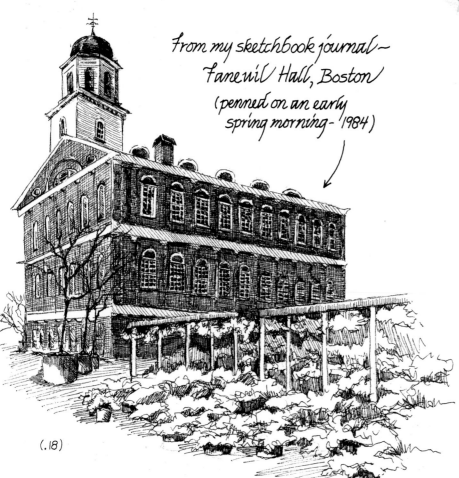

(.18)

132

Old North Church steeple where lanterns were hung to signal Paul Revere.
(.18 & .30)

Cupolas are small, dome-like structures that were built atop roofs, towers or steeples. They were used as belfries, lookouts, light towers or to admit light and ventilation to the building beneath them. Sometimes, they were merely decorative.

① Cylinder shape

Divide the cylinder into straight-sided sections that grow narrower towards the outer edges.

Cupolas may be square, circular or multisided. I find the polygonal shapes the trickiest to draw. It sometimes helps to begin with a basic cylinder shape.

② Adjust the top and bottom edge of each section into a straight line.

Add a roof, windows, trim, etc. that correspond to the various sections.

③

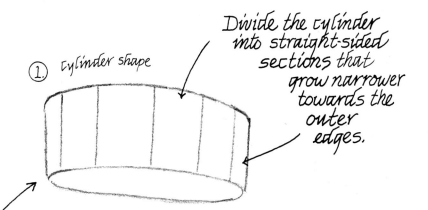

Louvered cupola, used for ventilation

(watercolor and colored pen and ink work)

④

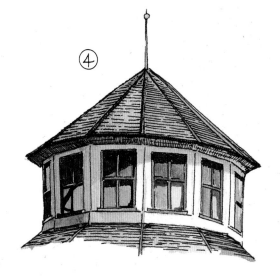

Square-shaped observation cupola on roof ridge.

Use pen, ink and watercolor to bring it to life.

Turrets

Turrets are small tower like appendages that are attached to the side or corner of a building, rather than free standing. They were commonly found on medieval castles. They also lend a fanciful elegance to many Victorian dwellings.

Pen and Sepia Ink (.25)

Basic cylinder shape

Pen, ink and watercolor wash using the Sepia hue! (.25)

Sepia watercolor washes (Detail work was done with a no. 2 round detail brush.)

VICTORIAN TOWERS AND TURRETS, 9¾″ × 7″ (25cm × 18cm)
Sepia and India ink pen work (0.25 and 0.50) overlaid with watercolor washes.

Gingerbread

The fancy woodwork used to embellish Victorian houses is often refered to as gingerbread. It took many forms, the most common being turned spindles, cutout scrollwork and layered wood pieces. Often the gingerbread was further decorated with painted scrollwork and bright colors.

Horseshoe-shaped gingerbread piece designed to fit in a gable.

This same gable piece, seen at a distance, is part of the painting shown on the opposite page. Note that there are fewer details shown because of the viewing distance. Ink outline work is also limited, to avoid a "cartoon look."

Drawing gingerbread —

① Begin by pencilling in simple geometric shapes. Draw the gingerbread within the confines of these shapes.

② Add details & scrollwork. Tracing your work and reversing it is helpful if you must produce a "mirror image" for the opposite side.

③ Finish your drawing in pen & ink,

paint or both.

Porch support gingerbread with painted scrollwork.

YELLOW AND GREEN VICTORIAN, 10″×8″ (25cm×20cm)
Layered watercolor washes accented with colored pen and ink texturing.

Victorian Studies —

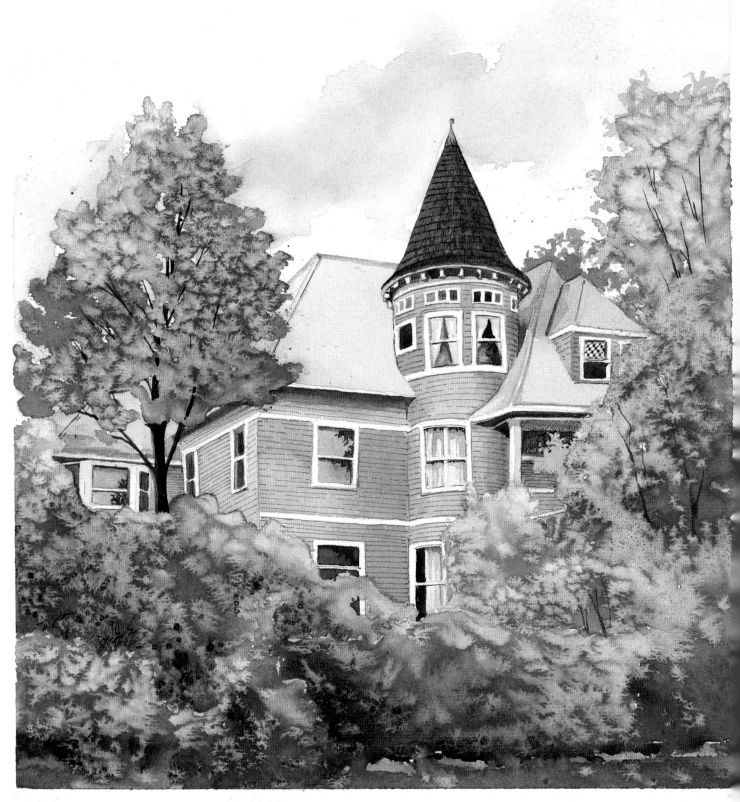

CRANBERRY HILL INN, 10″ × 8½″ (25cm × 22cm)
Watercolor wash, salt technique (foliage) and colored pen work (0.25).

VICTORIAN MANSION, 8¾″ × 7¾″ (22cm × 20cm)
Pen and ink (0.18, 0.25., 0.35 and 0.50).

Victorian Farmhouse In Sepia (.25)

Painted Lady

Sepia and Burnt Sienna pen work, on sketch paper, lightly tinted with water-color. (.25)

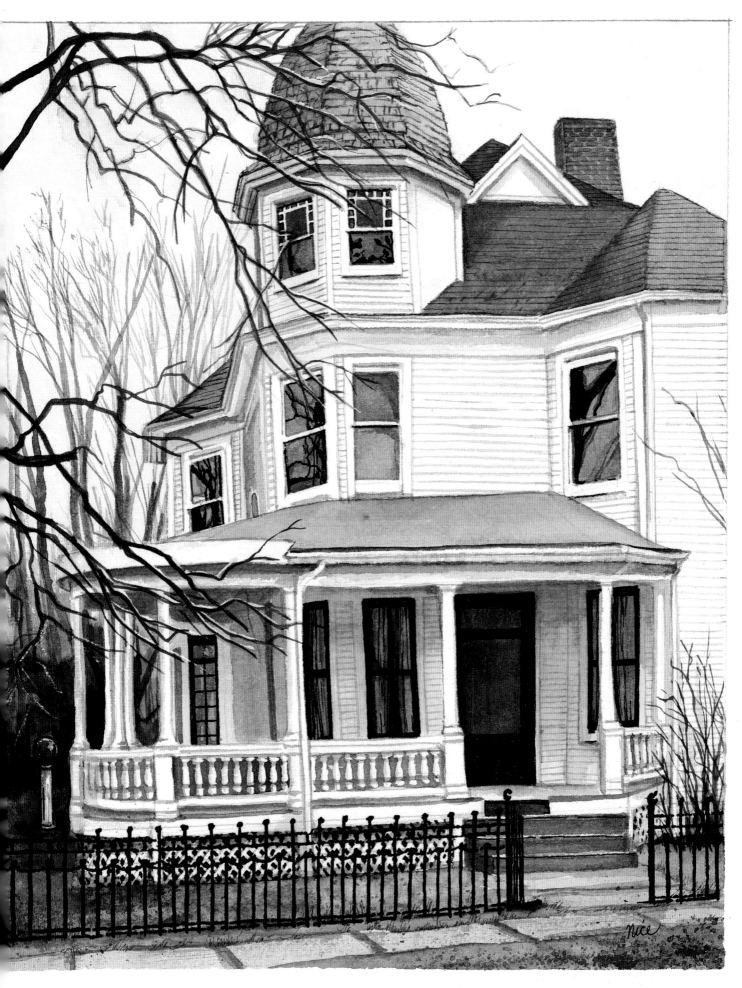

VICTORIAN IN WINTER WHITE, 10″ × 8″ (25cm × 20cm)
Layered watercolor washes detailed with pen work (.25 and 1.40).

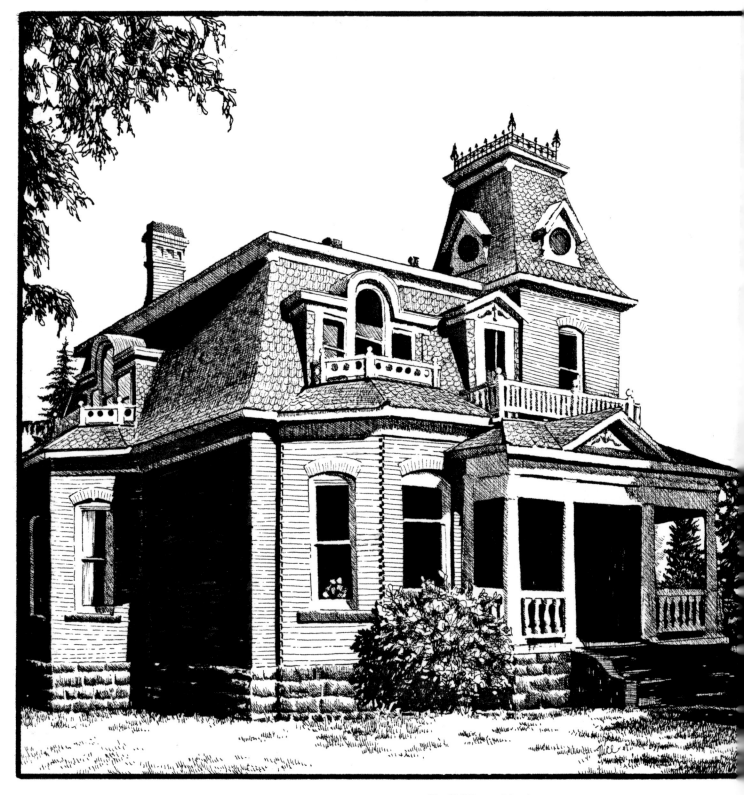

EATON HOUSE, UNION, OREGON, 8″ × 8″ (20cm × 20cm)
Pen and ink (0.18, 0.25, 0.50 and 1.40).

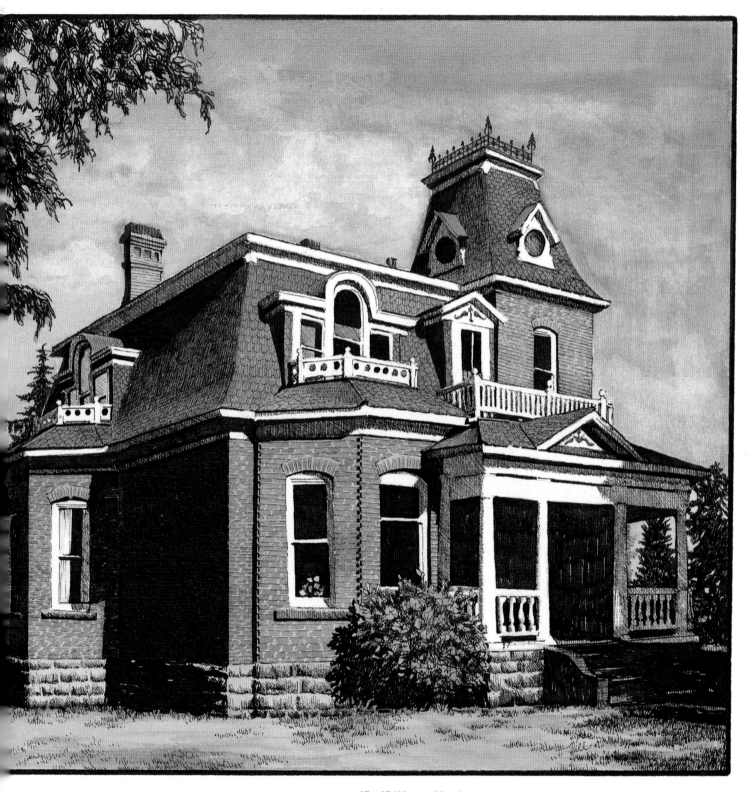

EATON HOUSE, 8″ × 8″ (20cm × 20cm)
Pen and ink with watercolor wash.

INDEX